STREET ART
FROM AROUND THE WORLD

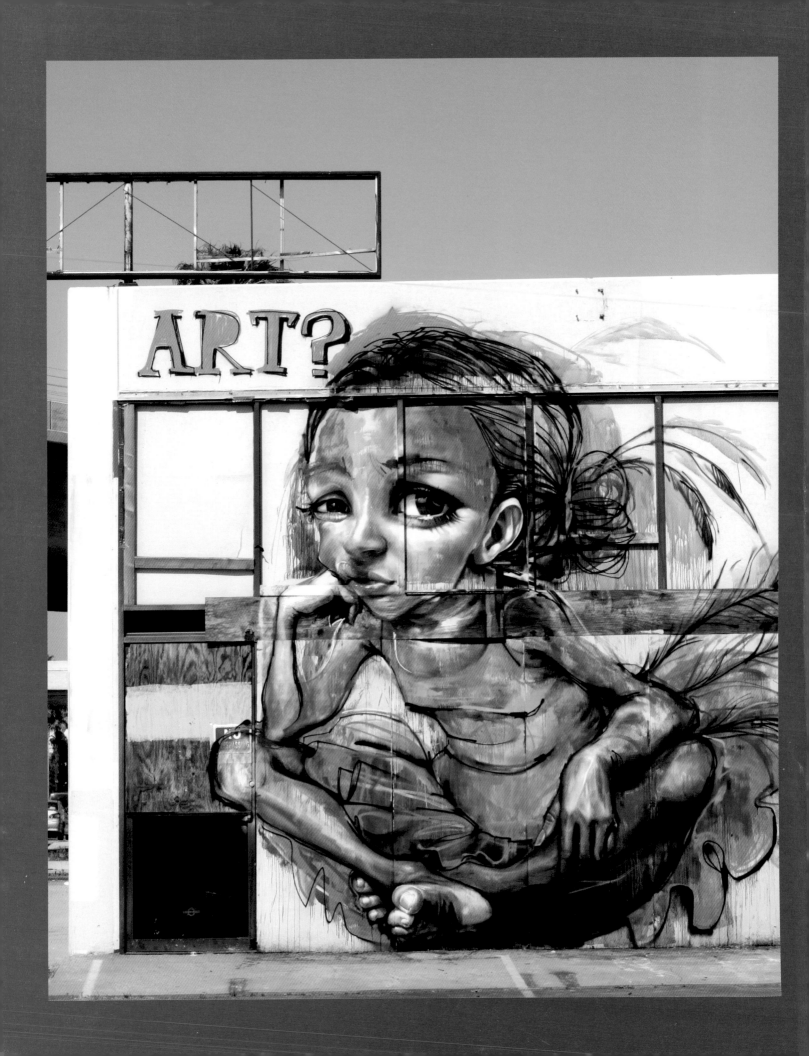

STREET ART
FROM AROUND THE WORLD

GARRY HUNTER

ARCTURUS

The author would like to thank the following for their support in the making of this book:

London
Manuel Sanmartin
Lucietta Williams
Graham Carrick
Ben Wilson
Julia Elmore
Dan Jones
ROA
Paul Don Smith
The Gentle Author
Matt Brown at Londonist
Sarah Hewson and John Burton at Urban Space
Trinity Buoy Wharf Trust

New York City
Steven P. Harrington and Jaime Rojo at
BrooklynStreetArt.com

Bristol
Morwenna, Olive and Richard Buck
Andy Adams

Berlin
Doralba Picerno

Newcastle
Lazarides Gallery

Sheffield
Michael Lindley

Brazil
Zezão

New Zealand
Bruce Mahalski
Sheridan Orr

West Africa
Angela Walker and Tom Sampson

For full photo credits see page 128.

ARCTURUS

This edition published in 2013 by Arcturus Publishing Limited
26/27 Bickels Yard, 151–153 Bermondsey Street,
London SE1 3HA

ISBN: 978-1-84858-540-9
AD002317EN

Printed in Singapore

CONTENTS

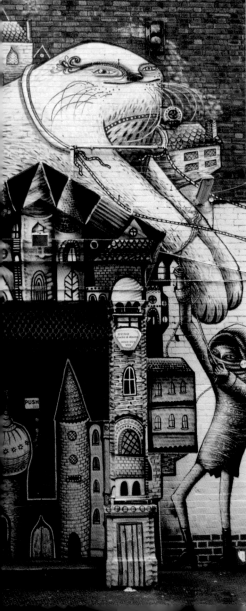

Introduction .. 6

CHAPTER 1 **STENCIL**

BLEK LE RAT .. 14

BANKSY ... 16

STENCIL ART IN BRISTOL, UK 22

C215 ... 24

EVOL ... 28

DON ... 30

STENCIL ART FROM AROUND THE WORLD 32

CHAPTER 2 **POSTER**

SHEPARD FAIREY ... 36

SWOON .. 40

EMA ... 44

JR ... 46

ACE .. 50

GAIA ... 52

POSTER ART FROM AROUND THE WORLD 56

CHAPTER 3 **PAINT**

BARRY MCGEE .. 60

BLU .. 62

ROA ... 66

JIMMY C .. 70

PHLEGM .. 74

STIK ... 78

EINE ... 80

BMD ... 82

OS GEMEOS .. 84

PAINT ART FROM AROUND THE WORLD 88

CHAPTER 4 **3D, MINIATURE AND OTHER MEDIA**

INVADER .. 94

VHILS .. 96

TOOTHFISH .. 100

CHEWING GUM MAN .. 102

NEK CHAND .. 104

FAILE ... 106

GENERAL HOWE .. 108

PABLO DELGADO .. 110

OTHER MEDIA FROM AROUND THE WORLD 112

Epilogue ... 114

INTRODUCTION

All around us, in the urban centres across the world, a creative phenomenon is taking place. Our towns and cities are saturated with the imagery of commerce and advertising, but alongside these there are also personal expressions of the modern human condition in the form of works of art on the street, available for everyone to see. Sometimes created under cover of darkness to avoid arrest, they are often considered temporary, being painted over or replaced by another piece within a few days. Increasingly, however, people have begun to recognize the power of this street art as a medium of expression, and its practitioners are coming out of the darkness and working on commissions and exhibiting in art galleries and cultural institutions.

As the 20th century drew to a close, street art was becoming firmly established as an accessible art form that was available to everyone and that went beyond the esoteric 'tag', the political statement or the religious affirmation. In order to examine this truly global phenomenon it is important to explore its origins at the very beginning of the built environment, when man started to construct his habitat and create territories away from the cave.

A HISTORY OF SELF-EXPRESSION

East Africa is often associated with the emergence of modern humans and it is here that the earliest evidence of the use of paint can be found. Man's first foray into art is thought to have been body painting – perhaps as part of hunting and worship rituals – using pigments ground from berries and earth, for which evidence has only recently been discovered. As these practices were evolving 300–400,000 years ago, we can only imagine the spectacle of the human body as a primeval canvas and it is largely unknown whether the drawings assumed abstract or figurative form.

The Chauvet-Pont-d'Arc cave in the Ardèche region of France contains the oldest known examples of figurative painting and small 3D sculptures of the female human form, work that dates back at least 35,000 years. The animals depicted here may be totemic ancestors or spirit guides, framed within the hunter-gatherer's experience of territory, family, threats and defence, and the fertility of both land and man.

The oldest known graffiti was carved by Semitic soldiers on an Egyptian cliff wall 4,000 years ago. It consists of two inscriptions that appear to contain a man's

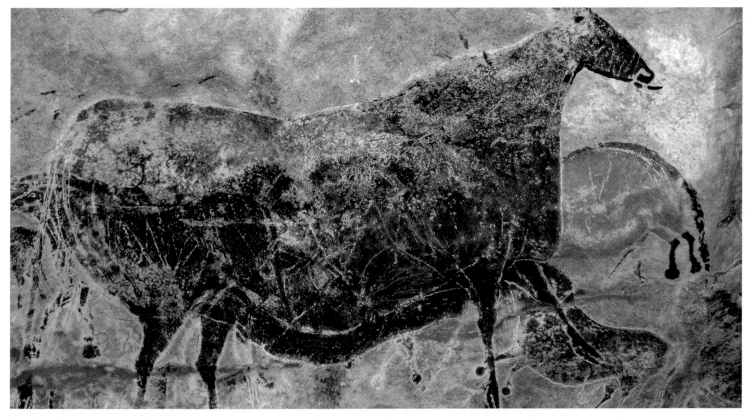

This Paleolithic painting of a bull at the Lascaux cave complex in France is one of the oldest known examples of figurative art in existence.

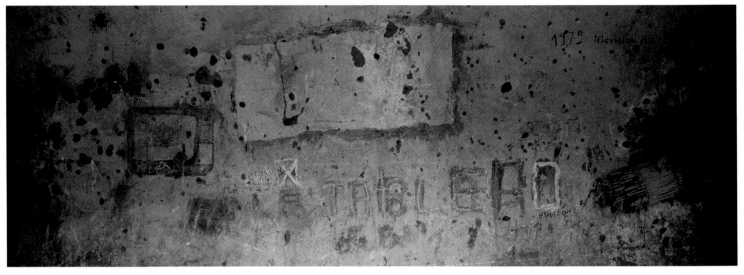

A television motif scratched into a wall in Niger, 1979: an example of how graffiti is used to mark social change.

name and a reference to God, and they represent the creative actions of individuals set apart from officially sanctioned hieroglyphics. Scratching into surfaces as a means of expression is still used throughout the continent in some places, as can be seen in the example above, which marks the arrival of television in West Africa in the late 1970s.

There are also many early examples of wall scratching in regions that were seen as 'cradles of civilization', such as the early metropolitan areas of Ancient Greece and Mesopotamia. Deriving its etymological roots from the Greek word '*graphein*' meaning 'to scratch, draw or write', 'graffiti' was also used in Ancient Rome as a common sign for secret societies, including early Christians who employed a simple fish symbol. This would appear temporarily chalked on subterranean routes to gatherings. It was also used as a test to identify others of the same faith when meeting on the street – if a curved sweep of the foot was answered with the reciprocal action that completed the fish cipher in road dust, further communication was safe. By their very transient nature, these moveable motifs provided a means of tacit communication in the earliest urban jungles and revealed coded trails that led to secret locations where various rites could be performed. In the event of discovery these ciphers could be easily disguised or removed.

As civilization developed, permanent figurative symbols became the simple method by which meanings could be communicated to a largely illiterate populace. These could involve the marking of territories or have political and religious significance within a pictorial narrative, or simply visually describe the name of a public house or a shop specializing in particular items. Examples of this can still be seen in Madrid, where, for instance, an image of a mail wagon lies above the road sign for Calle de Postas,

an example of dual public information employed since medieval times. The power of these simple images still informs and inspires the creation of much street art, the largely figurative content of which can be read easily in any language and does not require words.

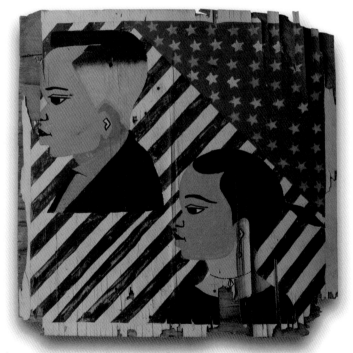

A street sign for a barber's shop in Senegal.

Carved symbols with anti-establishment content were popular in Shakespeare's time and many became ingrained in the structure of the Tower of London and other prisons as the accused awaited their fate. More recently, the journal *Antiquity* reported that drawings found in 2011 on walls in a property in London that was once occupied by members of the 1970s punk rock band The Sex Pistols are worth preserving and have as much cultural importance as ancient cave paintings.

WHAT IS MODERN STREET ART?

In the Western post-industrial age, there is still a desire for manual work and street art could be seen to fill this gap, especially for young people who would have once predominantly had more physical, hands-on professions. Urban sprawls that were once bustling centres famous for their coal, steel and cotton production are now quiet, and it is across the vacant walls of former factories, empty mills, closed mines, derelict warehouses and failed social housing projects that some of the most colourful social observations can be seen.

In centres of commerce – from London to Wellington, Paris to Saigon, Madrid to São Paulo and Berlin to New York – socioeconomic comments line the busy streets, on abandoned developments, metal shop shutters, car park walls and the pavements themselves. Armed with spray cans, stencils, paints and brushes, undercover artists decorate dystopias with wry humour and skills often learned on the job.

Street art is not just graffiti and, although textual markings are still central to the genre, this needs to be distanced from 'tags'. These are merely personal logos and have little importance in the most significant street art works, although artists may use a tag or signature within their works.

Where pure graffiti is seen as the often intangible output of a disaffected and uneducated youth, street art is associated with trend-aware college students who see it as an avenue to a successful career in the media. While this is sometimes true, there are many street artists who have graduated from tagging train windows with keys to producing innovative urban artworks with more altruistic objectives. Others started by altering advertising poster sites in the 1970s and 1980s, honing their craft with their original interventions. There are many crossovers that meld graffiti and street art, some of which have even developed into brands themselves, such as the Canadian Adbusters, a movement that became a magazine for the creative industry it once parodied.

The lines that once defined the two genres of street art and graffiti are now quite literally blurred, and practitioners can range from independent, clandestine artists to participants in community initiatives and savvy property developers. The cyclical game played by street artists and ad-men is an infinite loop. Reinterpreted logos placed in the environment become re-appropriated by advertising agencies for clients who see the benefit of streetwise publicity. Cross-fertilization of ideas is endemic in our furiously busy modern lives, where information is available at the touch of an online device and blends traditional disciplines with new media, with a certain nostalgia for good old-fashioned heroes and classic brand marks.

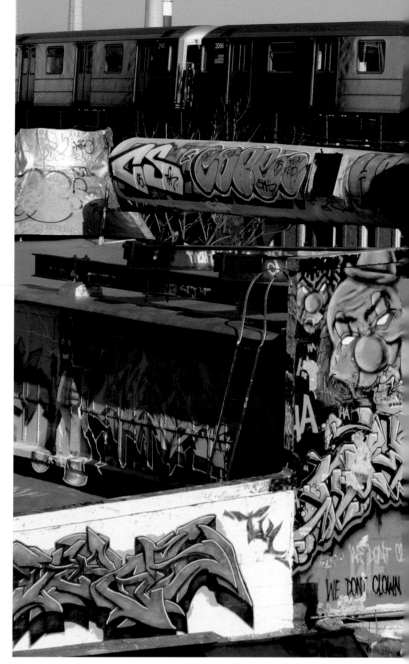

5 Pointz Aerosol Center, Queens, New York City, USA

BEGINNINGS OF A MODERN REVIVAL IN THE USA: PHILADELPHIA AND NEW YORK

Viewed as the ultimate urban centre in many people's eyes, New York City saw a proliferation of spray can art in the 1970s, most notably on subway cars. This movement had actually started in Philadelphia where large-scale pieces that emerged in the 1960s had redefined the medium, with political activists making statements and street gangs marking the boundaries of their neighbourhoods. This was rooted in 'bombing', first credited to Cornbread and Cool Earl, who wrote their names all over the city, a typestyle that only then migrated to New York City. Artists there used tag names referencing the street where they lived, such as TAKI 183 and Tracy 168, with their stylized vision appropriated as one of the four elements that comprise hip hop,

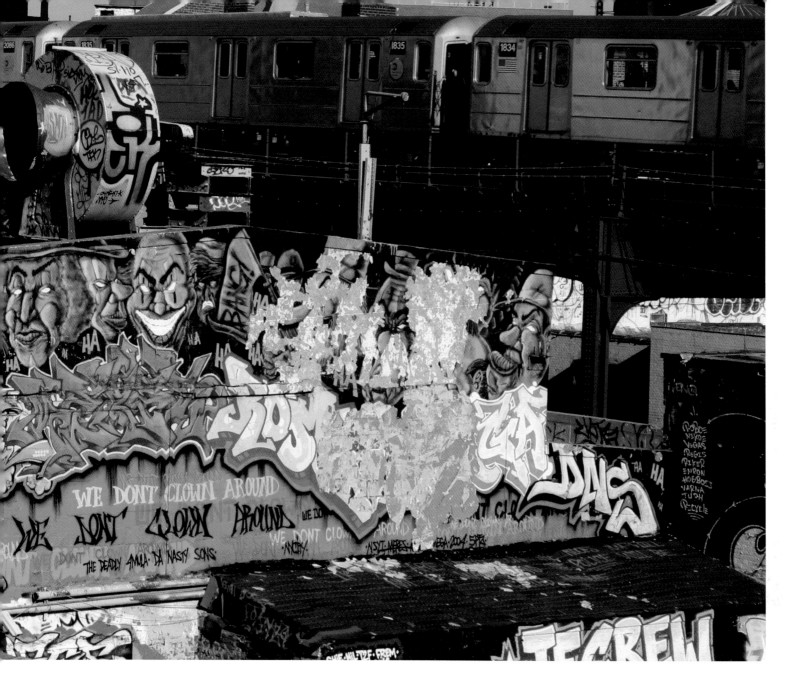

alongside breakdancing, DJing and rapping.

The dissemination of street art into popular culture was neatly encapsulated in Terry Gilliam's 1995 movie *Twelve Monkeys*, which uses a street art motif as the central cipher in its twisting plot. Filmed in Philadelphia, locations include the semi-derelict site of Eastern State Penitentiary, a ghostly labyrinth that now has its own commissioning arts programme. The trend for buildings with former corrective or industrial uses becoming favourite sites for graffiti artists facilitated their transformations into official gallery spaces. As the work spread out on to the street itself, Philadelphia began to accumulate a huge number of giant murals. Many of these were commissioned by the city institutions themselves, while others were part of grassroots community arts rebuilding programs or simply created by individuals working independently.

Street art is indelibly watermarked by hip hop in the USA, and the same could be said of Banksy's hometown and the birthplace of trip hop – Bristol. Graffiti artist Goldie joined a breakdance crew the Bboys and his street artwork featured heavily in Afrika Bambaataa's documentary *Bombing*. Goldie took part in the largest-ever British graffiti art battle alongside Bristol artist Robert '3D' Del Naja, who later formed the band Massive Attack. This crossover of visual art into music marked a homogenization that was to define creative practice in the late 20th and into the early 21st centuries.

Harlem and the South Bronx were the epicentre of the golden era of New York subway graffiti, a revolution of visual imagery that evolved into the elaborate, continuously interweaving 'wildstyle.' Little wonder then that subway cars became the canvas when street art literally went underground in the early 1970s.

This constantly moving frieze of brightly coloured tags became such a recognizable element of the city that a large museum dedicated to the medium opened right next to the Seven subway line in Queens. 5Pointz Aerosol Center is an ever-evolving 'living' museum and walkable gallery that was established in 1996. The name symbolizes the place where the 'Five Boroughs' converge, and was used on the Beastie Boys' album of the same name that recognizes the huge significance of graffiti and subway cars in the culture of New York City.

By contrast, in the American West, the motor car became the icon that was used to create street sculptures from Carhenge in Nebraska to The Cadillac Ranch in Texas. Here, aerosols were again used to decorate the pieces, as on the East Coast subway trains, rooting these thoroughly American road trip icons firmly in the landscape.

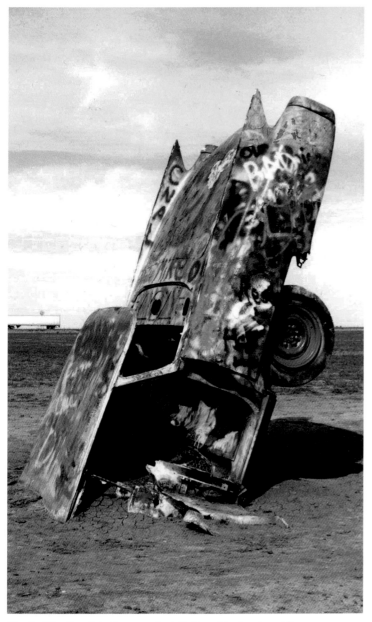

The Cadillac Ranch in Texas, an installation of junk automobiles.

TERRITORIAL ROLE

At the same time that the modern revival of graffiti in the West was occurring, a parallel movement was emerging in Eastern Europe, where the Berlin Wall became a massive outdoor canvas on which to express doctrines of political freedom and the emotions of friends and families torn apart by this concrete curtain. In Hungary, however, the spray paint on walls was more consumer-led and aspirational, and odd endorsements of Western brands screamed 'Levi 501s!' or 'Benetton!'

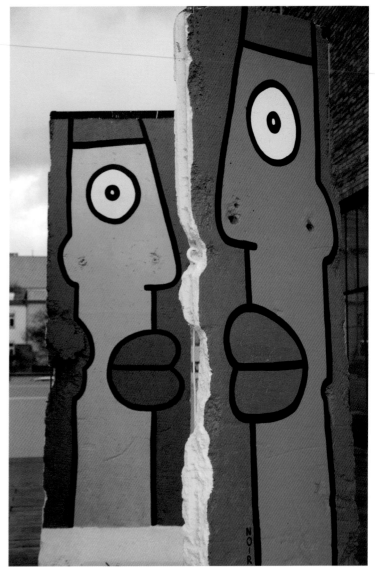

Paintings by Thierry Noir from the Berlin wall.

Localized territory defined by religious divides became particularly poignant in Northern Ireland, where there are over 2,000 street sites of political art that expressed allegiances and where Loyalist and Republican communities met head on. In Derry, the pro-British paintings remain much the same, focused on the Union Jack and the Royal Family, whereas the reunification movement moved on to feature broken rifles and symbols

of peace after the ceasefire agreement was reached.

Territorial rivalry also occurs between street artists themselves. As the most famous street artist in the world today, it is almost inevitable that Banksy has to battle rivals out on the street. The most long-standing of these conflicts is with the South London outfit Team Robbo, who enter into street art duels over particular locations where one or the other has placed a piece. This still occurs when anxious shop owners make efforts to preserve Banksy's work on their walls, often protecting it with Perspex. This then becomes a transparent surface for new additions while preserving the original in an urban aspic.

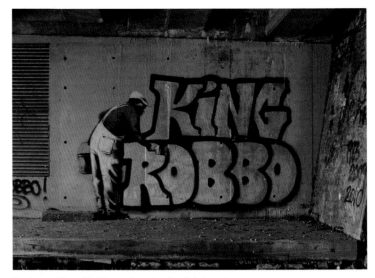

Banksy v. Team Robbo at Camden Lock in London.

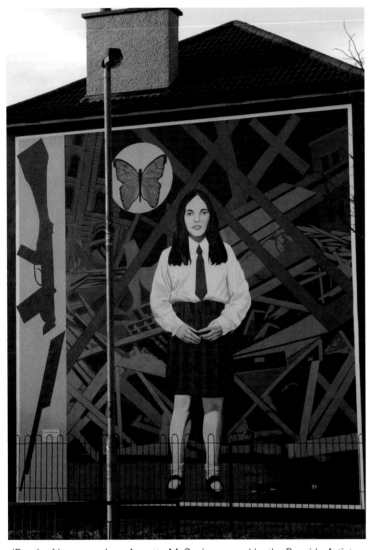

'Death of Innocence', an Annette McGavigan mural by the Bogside Artists, Derry, Northern Ireland.

STREET ART TODAY

Today, street art is a global phenomenon that has blossomed since the start of the credit crunch that began in 2008, when personal expression communicated the frustration that most people felt with corrupt systems of business, banking and politics. In the Arab Spring of 2011, stencilled pieces appeared all over North Africa, with many voicing a similar communal opposition to political and financial elites.

Most street art is less overtly political and uses classical themes that communicate man's eternal relationship with nature in the urban environment and challenges our perceptions of modern society. Far from reaching its peak, street art is constantly evolving, reaching into new avenues of interactive installation, utilizing found items

A stencil by Egyptian artist Keizer in Cairo.

and new materials to house the imaginations of cutting-edge practitioners.

This book showcases work by leading contemporary street artists, examining each of their individual practices that utilize stencils, posters, paint or mixed media.

Photography by the author, Jaime Rojo, Doralba Picerno and contributors from around the world encapsulates a movement that is gaining attention wherever an artist picks up a brush, a roller, a spraycan or one of the many other innovative tools that are taking street art into new areas.

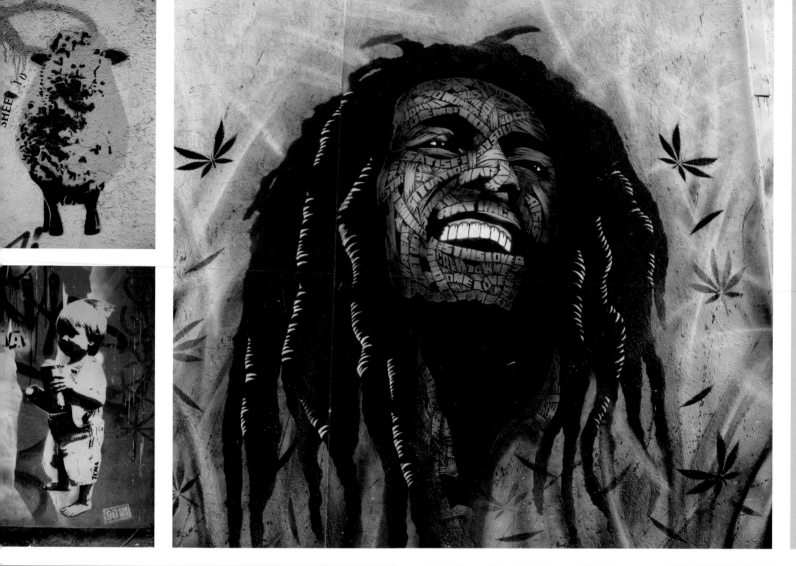

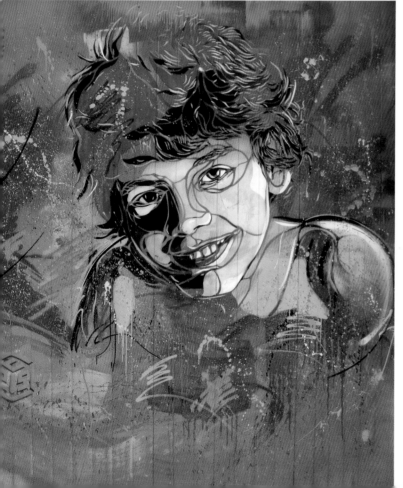

CHAPTER 1

BLEK LE RAT

from Paris, France

The origins of the stencilled rat have a thoroughly European pedigree. As an anagram of 'art', the rat is an iconic urban creature, its largely subterranean existence mirroring our own surface occupation of cities. It is fitting, therefore, that this rodent became the central star of the new European street art tradition that began in the early 1980s. Innovative Parisian street artist Blek Le Rat pioneered the use of stencilled animals in order to avoid imitating the American graffiti he had seen in New York a decade earlier, and described the rat as the only truly free animal in the city, one which spreads the plague everywhere, just like street art.

The metamorphosis of humans into animals has long existed in mythology, including in ancient cave drawings such as *The Sorcerer* at Les Trois Frères, France. More recently, a subculture has developed to describe 'therianthropes' as having a psychological identification with non-human animals, with the rat being the perfect alter ego for an artist trawling the city at night.

In a recurring motif, Blek Le Rat pictures himself with a bag of belongings and a destination label that can contain a national flag or a city name, often set alongside the stencil of a sheep, introducing a traditionally rural animal into the cityscape.

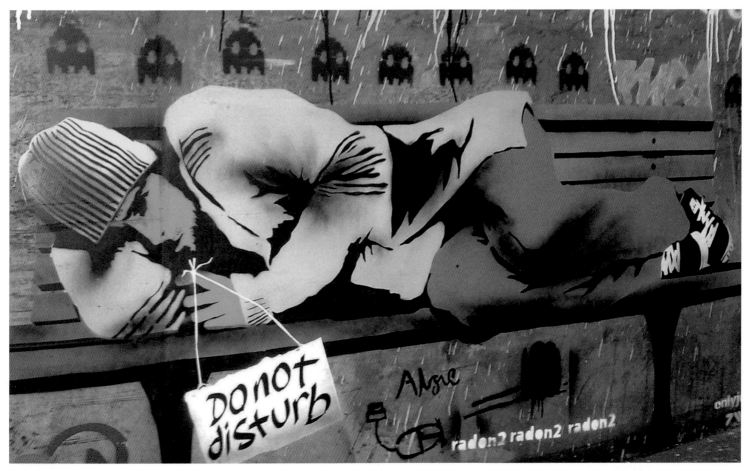

Paris, France

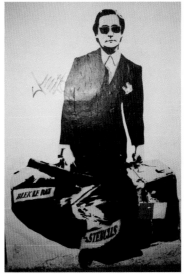

Paris, France

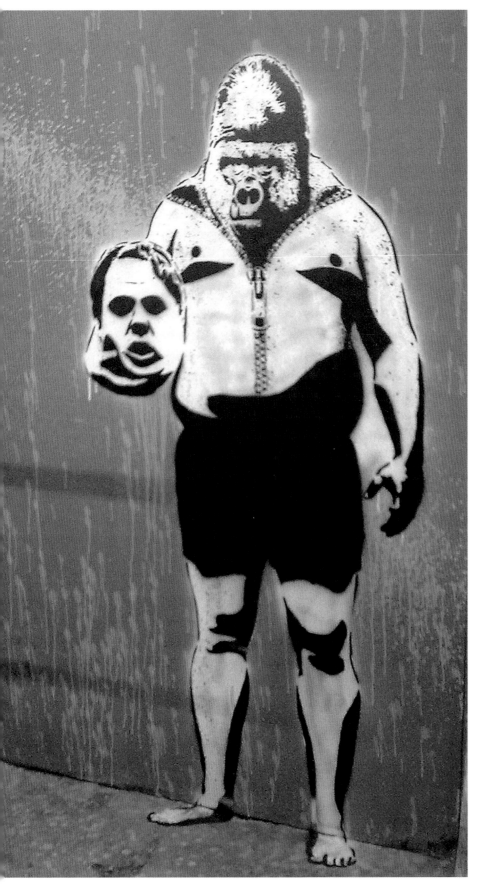

Paris, France

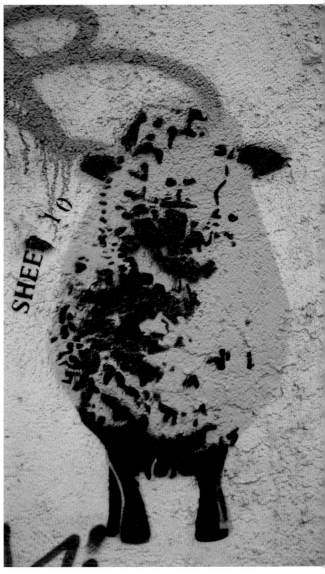

Berlin, Germany

15

This artist needs little introduction, as these days any appearance of his work almost anywhere in the world is guaranteed to create a media stir and a flurry of admirers to document and distribute online images of his latest pieces.

The rat has also become world-famous as one of Banksy's most recognizable characters, more prevalent than even his name tag, a chiaroscuro rodent that assumes the mysterious identity of the artist and is often depicted within the work holding a dripping paintbrush or spray can.

Quoted in the British tabloid newspaper *The Daily Mail* in 2008, Banksy acknowledged Blek Le Rat's influence, saying: 'every time I think I've painted something slightly original, I find out that Blek Le Rat has done it as well, only twenty years earlier.' Blek's responses have swung from generously adding to an existing Banksy piece in San Francisco to claiming credit for many Banksy icons and doubting the younger artist's integrity.

Even though his work at auction commands huge prices and is collected by the rich and famous, Banksy still demonstrates support for worthy causes in his home city. He produced a limited edition print to help out activists in the Stokes Croft area of Bristol who were fighting the development of a community space and faced a huge legal bill (see page 21). Sales of the print – showing a Molotov cocktail that poked gentle fun at a major supermarket chain who were moving into the area and putting the local independent shops at risk – raised £10,000. Ironically, Banksy's own work has been the victim of bright blue paintbomb attacks. Fortunately, Bristol City Council have restored some of these as they recognize the value of street art.

BANKSY

from Bristol, UK

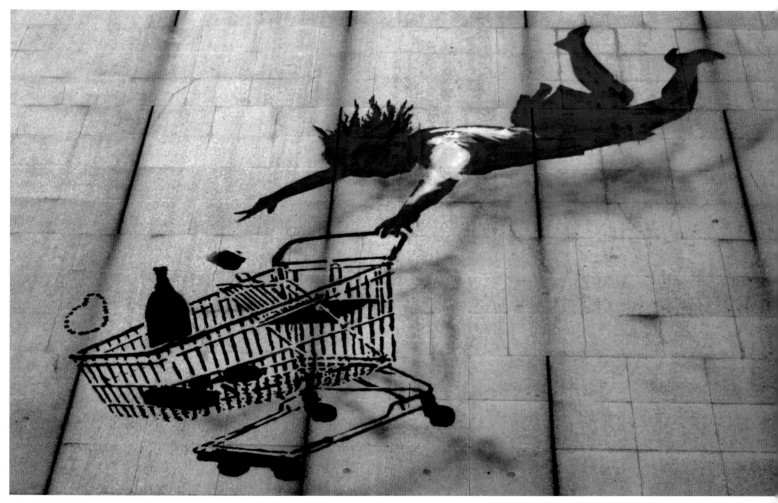

London, UK

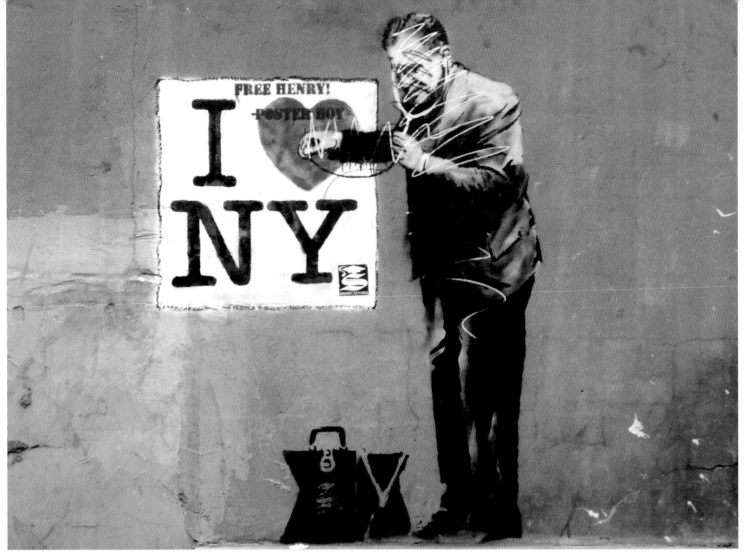

New York City, USA

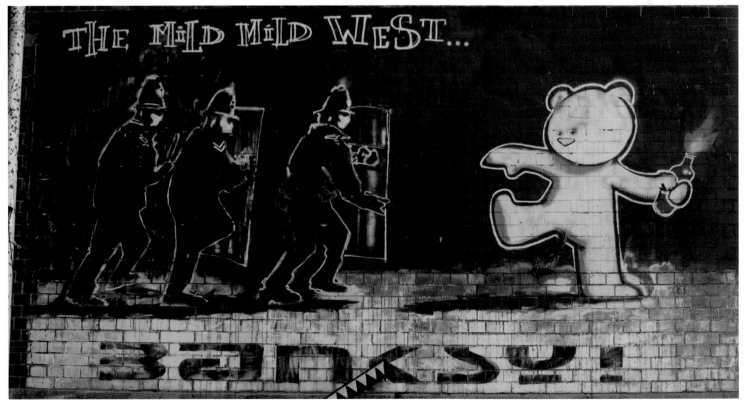

Bristol, UK

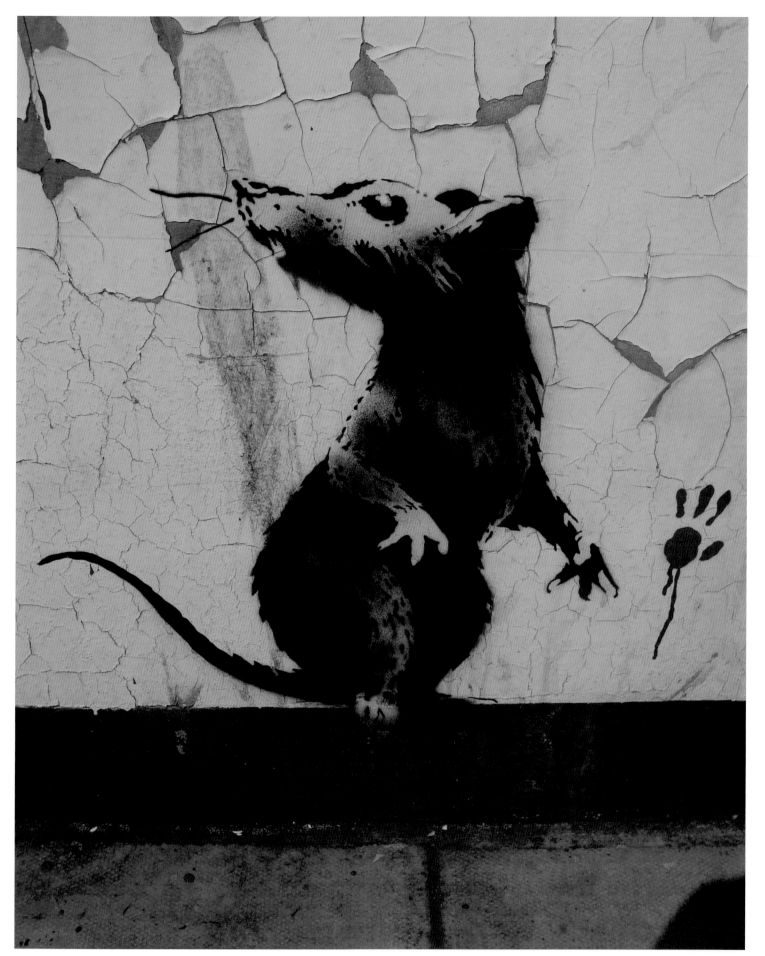

London, UK

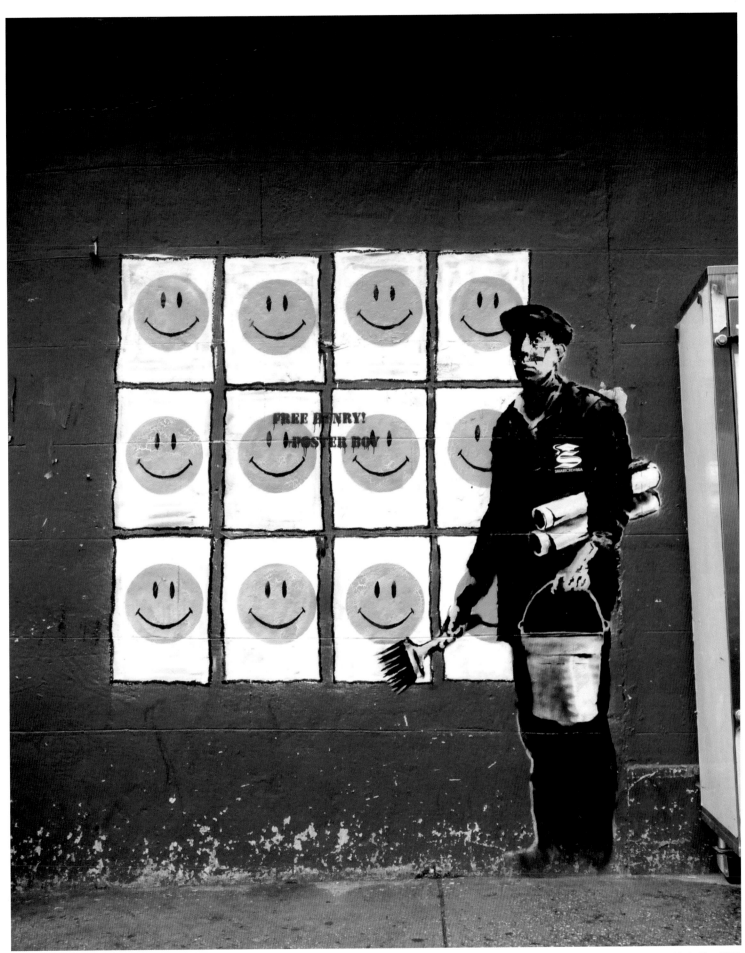

New York City, USA

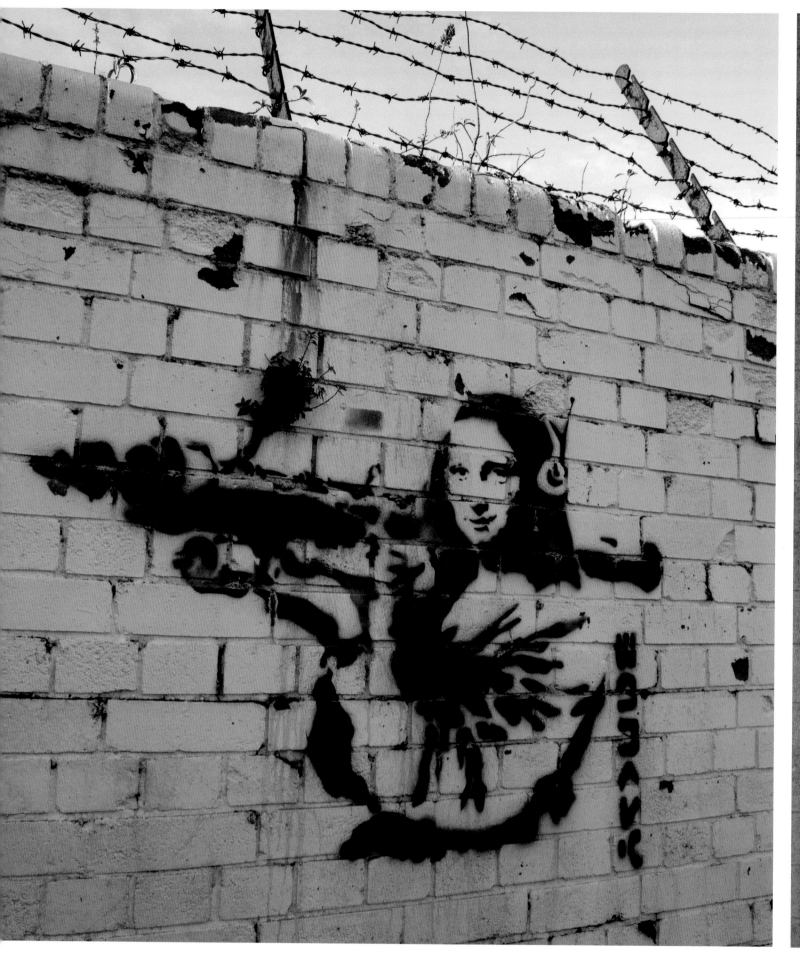

London, UK

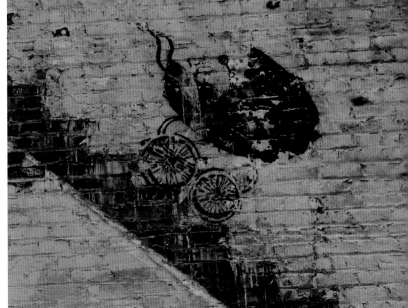

Chicago, USA

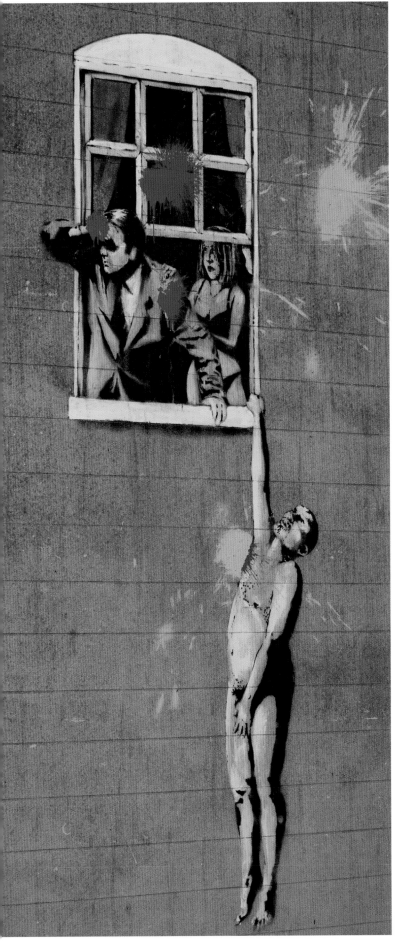

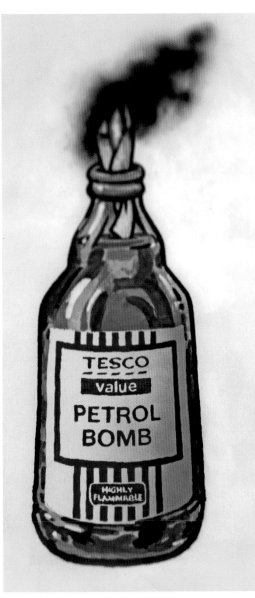

Bristol, UK

Banksy limited edition fundraising print

Pure Evil

Unknown artist

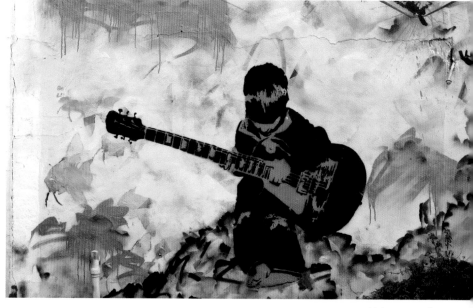

Unknown artist

Banksy's home town of Bristol has a rich history of dissent, where small cores of people have brought about significant changes through non-violent actions. This has recently stemmed the corporatization of the Stokes Croft neighbourhood of the city, famed for its range of independent retailers. The key to this movement is a vibrant street art scene that now has global notoriety, attracting many international practitioners to literally make their mark in this self-proclaimed 'People's Republic'.

Unknown artist

STENCIL ART

in Bristol, UK

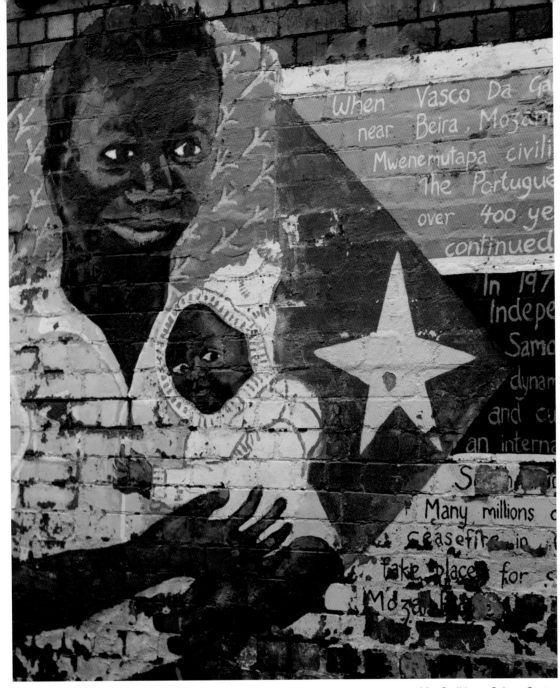

When Vasco Da Ga... near Beira, Moza... Mwenemutapa civili... The Portugue... over 400 ye... continued... In 197... Indepe... Samo... dynam... and cu... an interna... S... Many millions... ceasefire... take place for... Moza...

Afro Caribbean Culture Centre

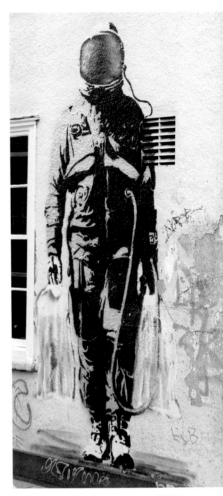

SPQR

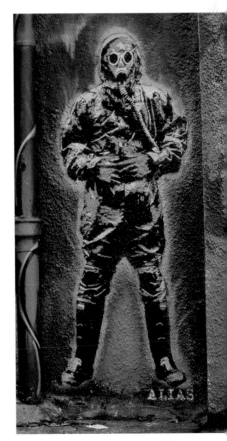

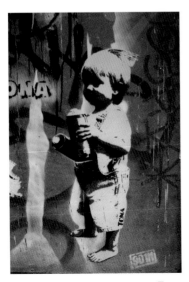

The nearby area of St Pauls has a strong multicultural heritage. This is reflected in the vintage murals at the Afro Caribbean Culture Centre (above), which narrate the forced journeys of West Africans to the plantations of the colonies, often via Bristol, which was a major British hub during the slave trade.

Tona

Tona

Alias

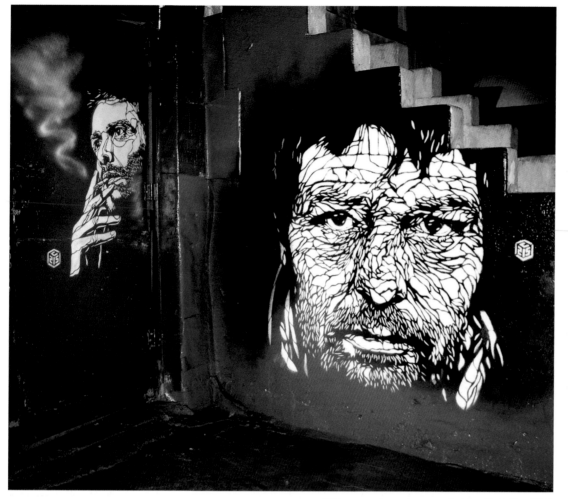

All images shown here are in New York City, USA

C215

from Vitry-sur-Seine, France

With a nod to the New York graffiti artists of the 1970s who referenced abbreviations of their street addresses in their tags, this artist identifies himself using the first letter of his Christian name and the number of the room where he was living when he started his street art work in the early 1990s. After managing a collective of 200 artists, he began to use stencils in 2006 and has worked extensively in his home country, the former French colonies of Morocco and Senegal, as well as in India, Israel, Poland, Russia, the UK and the USA.

As an orphan himself, C215 has a true empathy with abandoned children and the dispossessed people of the world, and usually chooses placements for his work that could be street-side refuges for the homeless.

His incredibly detailed stencilling gives voice to forgotten individuals, which as a collective work presents a strong social comment that can be understood globally.

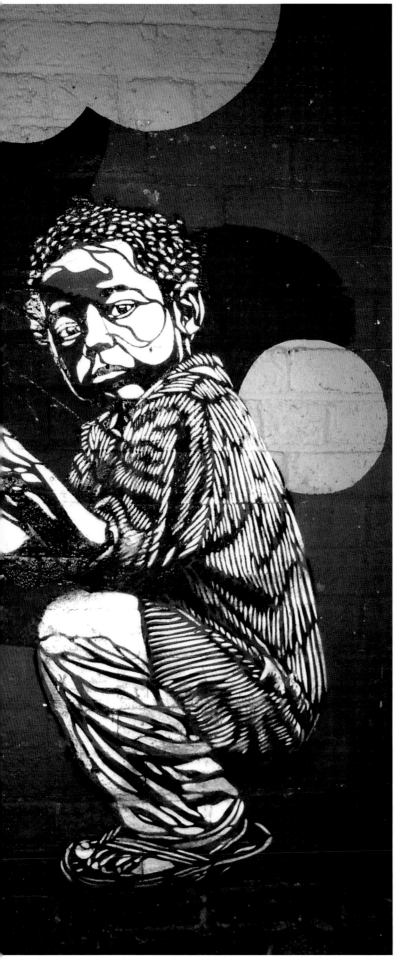

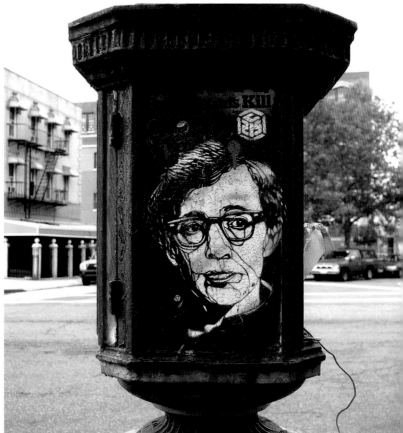

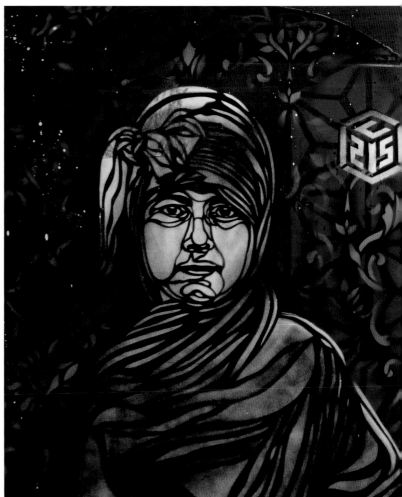

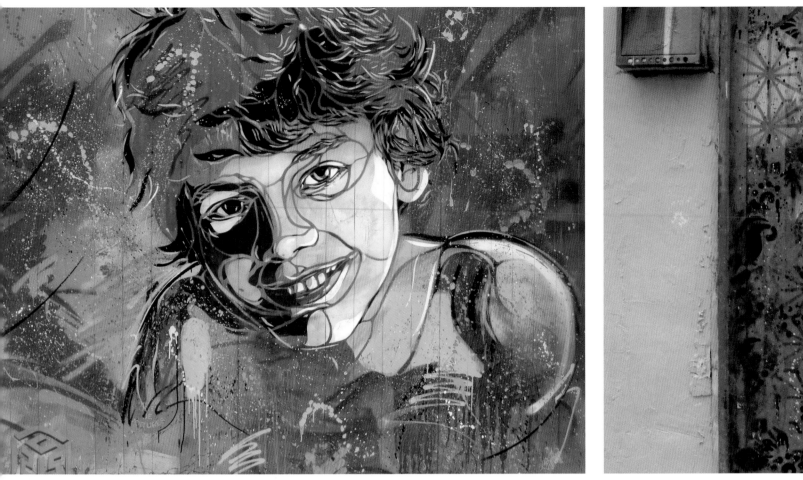

All images shown here are in Paris and the Parisian suburb of Vitry-sur-Seine, France

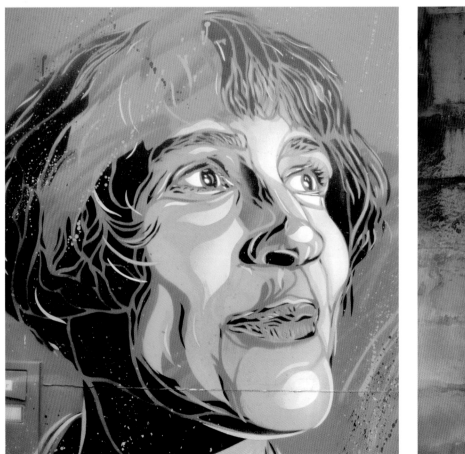

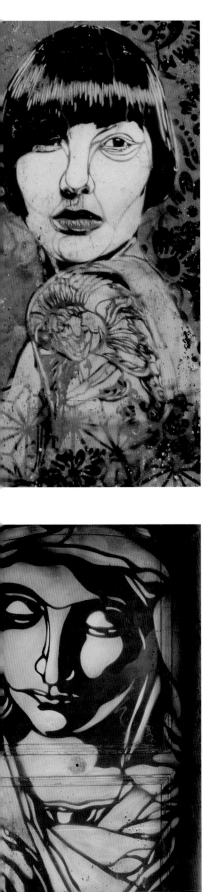

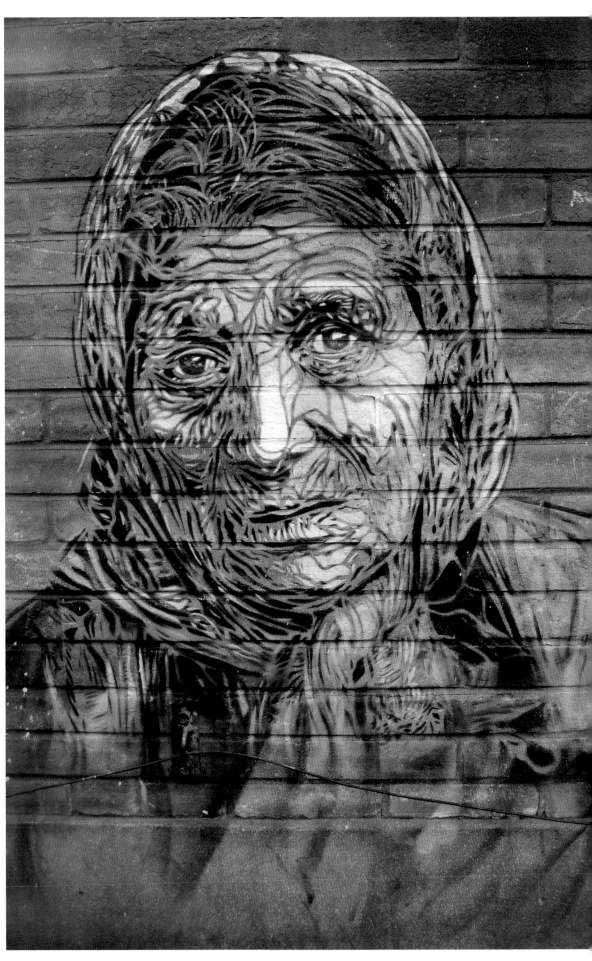

All images shown here are in London, UK

evol

from Heilbronn, Baden-Württemberg, Germany

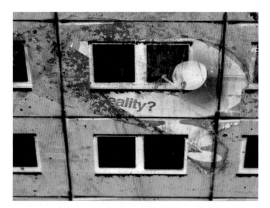

vol could be 'love' spelled backwards, a verbal trick that has also been employed by alternative rock bands such as Black Rebel Motorcycle Club. The word is also a shortened version of 'evolution.'

Using tiny stencils, this artist transforms street furniture such as telephone junction boxes into scaled-down replicas of faceless housing blocks, showing the isolation they cause among their tenants, disconnected from the rest of society around them.

In a slaughterhouse in Dresden, a city infamously firebombed by the Allies in the Second World War, he first made existing concrete slabs into miniature apartment blocks that reproduced the enormous scale of his former Berlin home on a modernist estate.

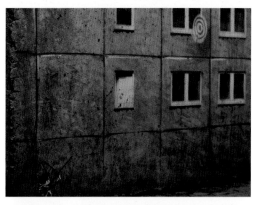

Then, on the edge of London's Smithfield meat market, he transformed concrete barriers into an anglicized version of the grey, sprawling housing estate by including stencils of typically British icons, such as a young Robin Hood-type character, the St George's flag of the English patriot and the satellite TV dishes that receive live football coverage.

In the gallery environment, Evol spray paints on to cardboard constructions, exhibiting at solo shows in Berlin, Brussels, London, Shanghai and Pforzheim, a city in the artist's home state of Baden-Württemberg that also suffered huge bomb damage during the Second World War.

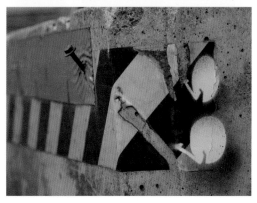

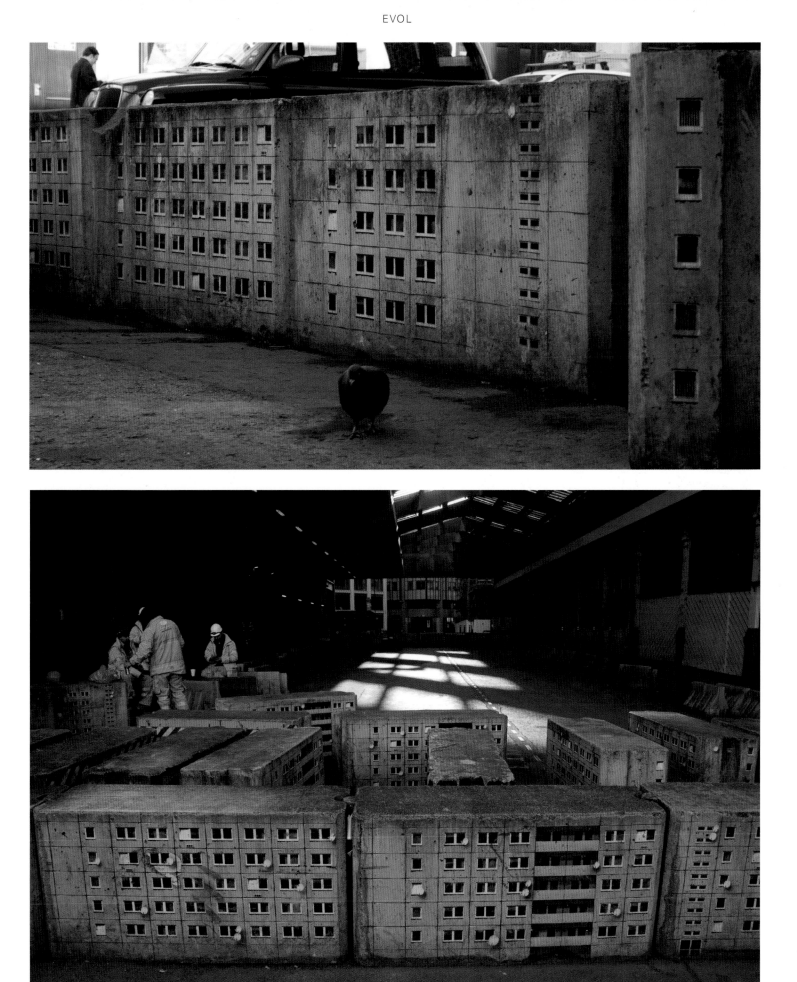

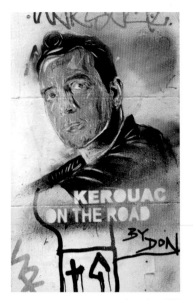

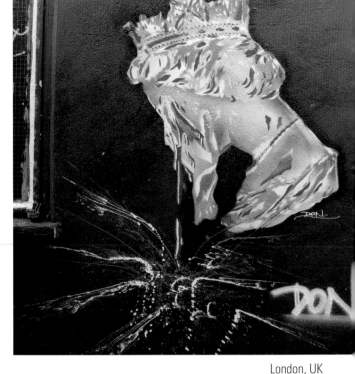

London, UK

London, UK

London, UK

DON

from Surrey, UK

iting French stencil pioneer C215 as a major influence, Paul 'Don' Smith has developed a process using multiple layers of hand-cut paper stencils that resemble contour lines on a map. Half a dozen separate versions are sprayed through on an overlapping final image that has depth and deep shading with flourishes of sprayed spots. The consistency of the paint is regulated by the artist, who stows the spray cans inside a thick jacket on cold days while the separate layers are being taped to the wall.

Don takes iconic figures such as Amy Winehouse, wild animals and members of his family as subjects, and his works include a particularly poignant portrait of his son on the corner of Redchurch Street in Shoreditch, London (below), that looks out over a bucolic scene containing an owl and a deer.

His bowler-hatted 'tap man' appears on the exteriors of certain financial corporations in the City of London, perhaps providing a comment on the endless flow of public money that has kept them solvent.

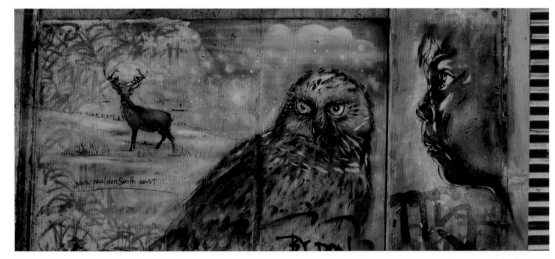

London, UK

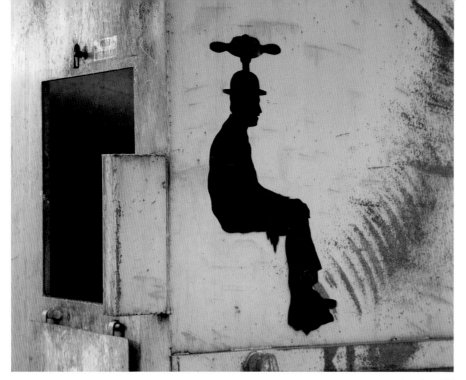

London, UK

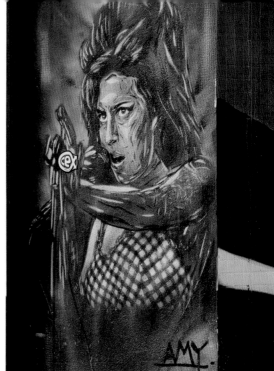

Bristol, UK

London, UK

31

STENCIL ART

from around the world

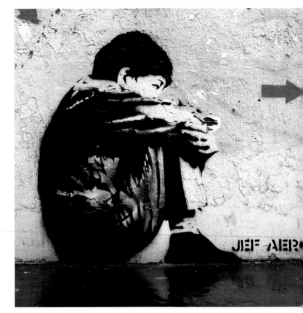

Jef Aérosol, Paris, France

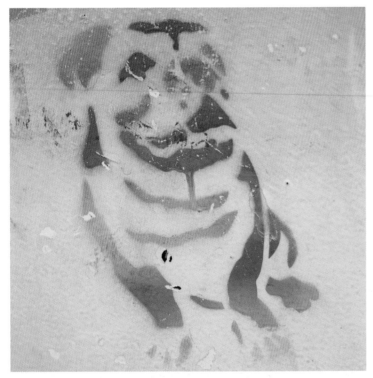

Unknown artist, London, UK

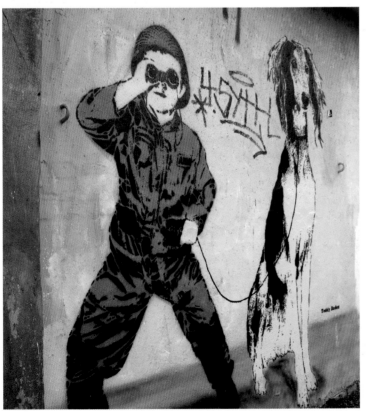

Teddy Baden, London, UK

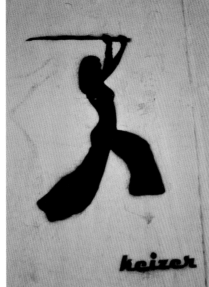

Unknown artist, Rome, Italy

Keizer, Cairo, Egypt

Unknown artist, London, UK

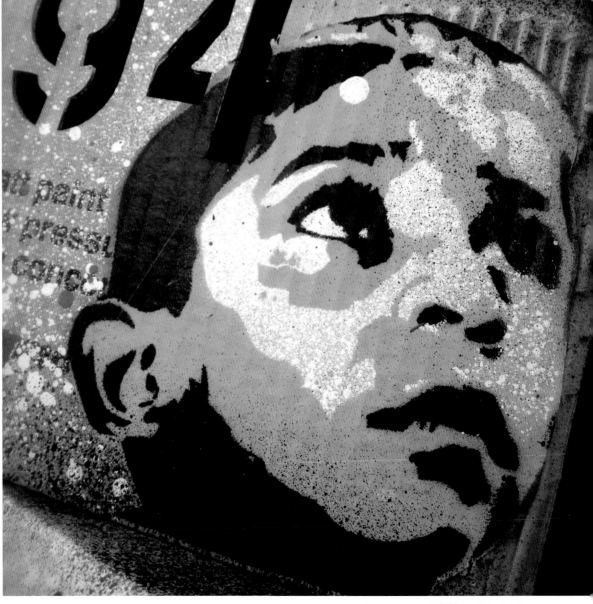

Unknown artist, London, UK

Jef Aérosol, Paris, France

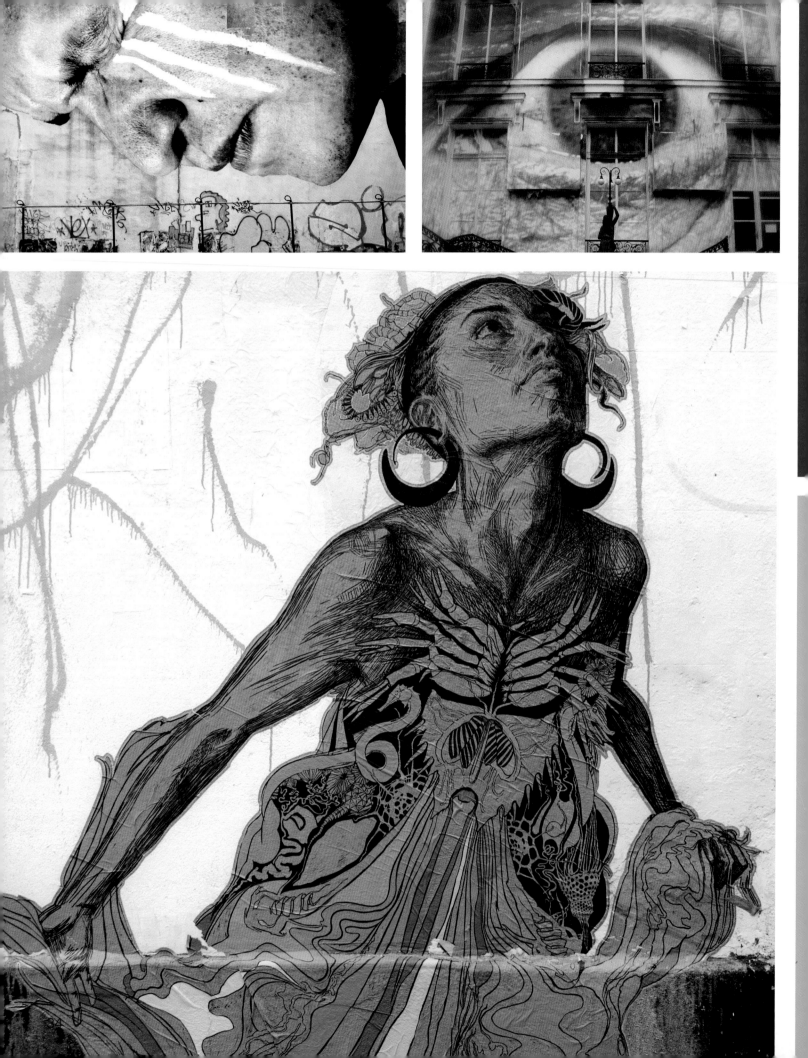

CHAPTER 2

SHEPARD FAIREY

from Charleston, South Carolina, USA

This artist's work encapsulates street art within a graphic design practice that stemmed from the genre of skateboard art. His most widespread creation *Obey* appears to be the face of a mysterious cult leader (see page 38), but is rooted in popular culture, drawing influence directly from a slogan employed by professional wrestler Roddy Piper in John Carpenter's movie *They Live*. The *Obey* website certifies that: 'The sticker has no meaning but exists only to cause people to react'.

By contrast, Fairey also created posters directly backing Barack Obama's candidacy for President of the USA. This series included the now legendary *Hope* portrait (with the alternative version *Progress*, see opposite) which the *The New Yorker* dubbed: 'the most efficacious American political illustration since 'Uncle Sam Wants You''. Fairey distributed 800,000 stickers and posters during his self-funded campaign for real political change.

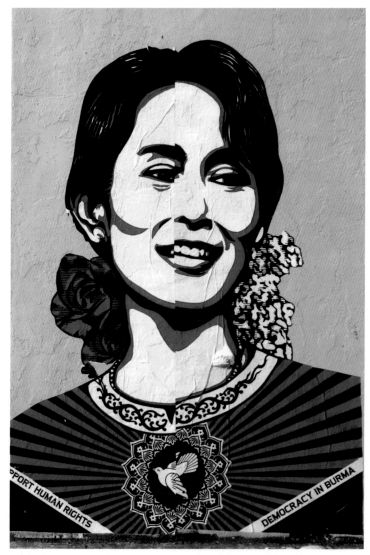

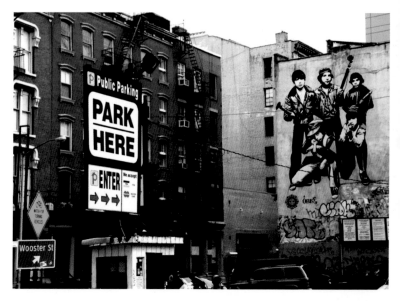

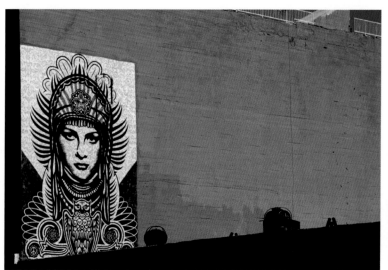

All images shown here are in New York City, USA

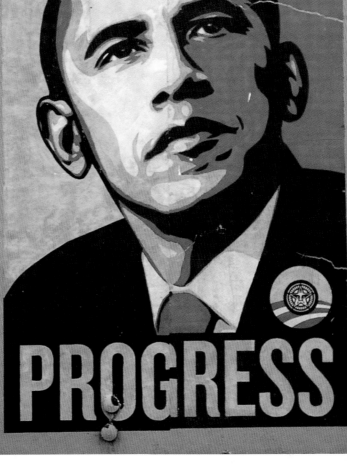
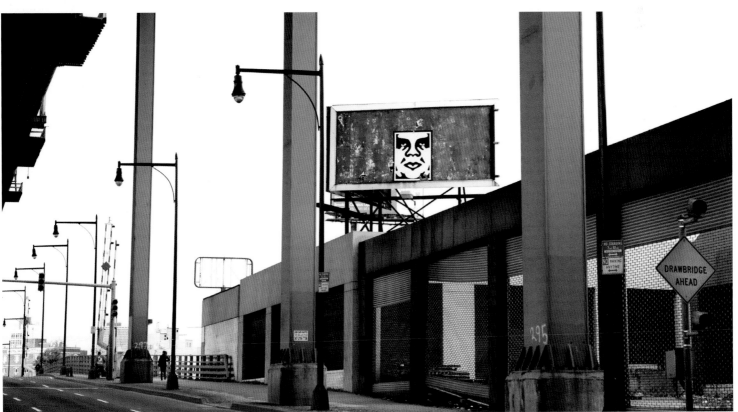

Newcastle, UK

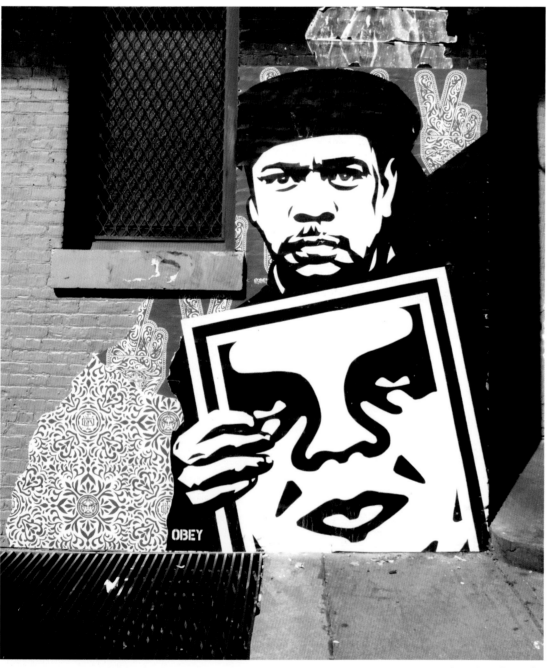

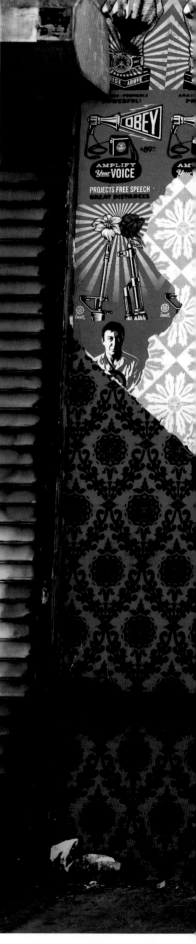

New York City, USA

New York City, USA

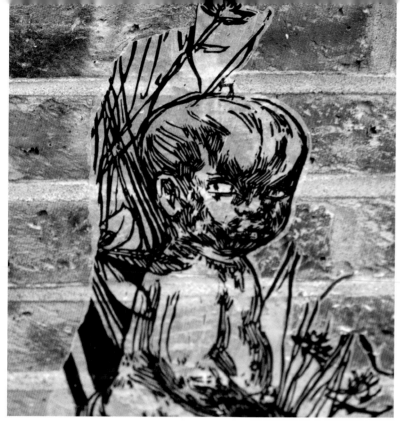

London, UK

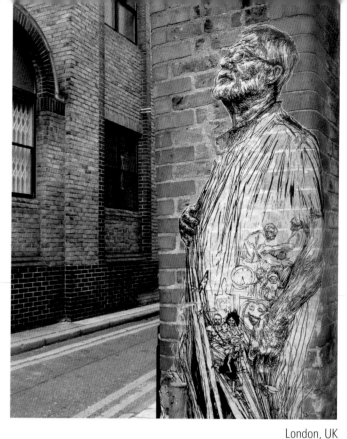

London, UK

SWOON

from New London, Connecticut, USA

New Orleans, USA

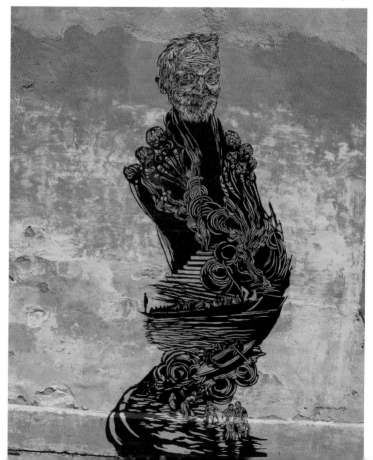

As a leading exponent of the wheatpaste process, this New York-based artist takes historical folk art and woodblock printing as her primary inspiration. She produces eloquent posters that appear on previously blank spaces, ranging from fire escapes and water towers to residential street walls and the exteriors of abandoned buildings. She is also involved with a number of arts collectives and activist groups including Transformazium in Pennsylvania and the Konbit Shelter sustainable housing project in post-earthquake Haiti, which involves the creation of adobe 3D spaces.

Swoon bases her characters on real people that she has met, and has decorated sections of the Regent's Canal in London and the Venice Biennale with bespoke work that follows the curve of an arch on a canal bridge or reflects the shape of a building. Waterways play a major role in much of her art, including the Swimming Cities project, which includes mobile versions of her art that express environmental concerns.

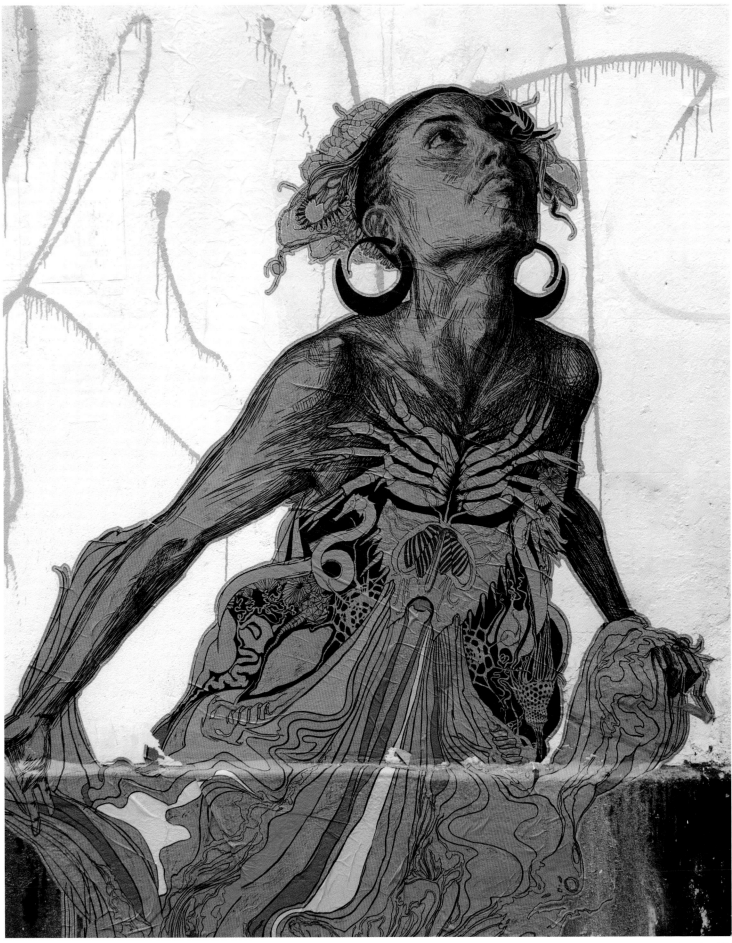

London, UK

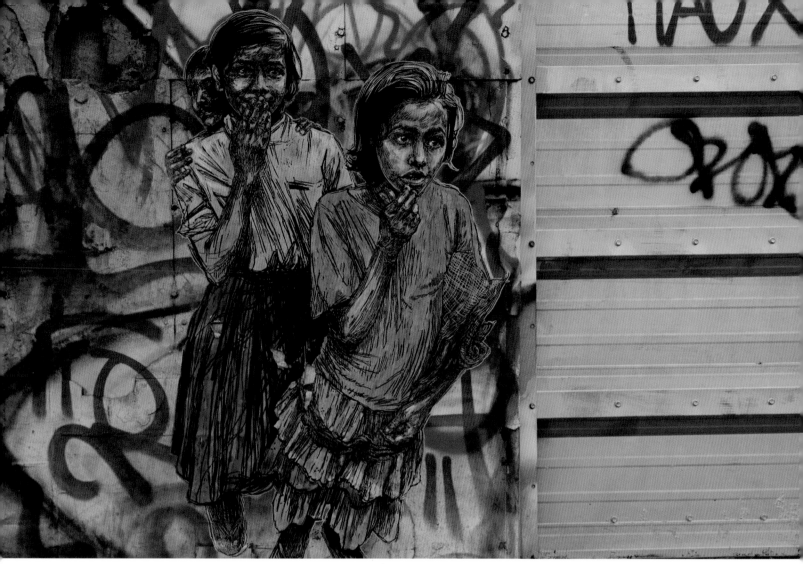

New York City, USA

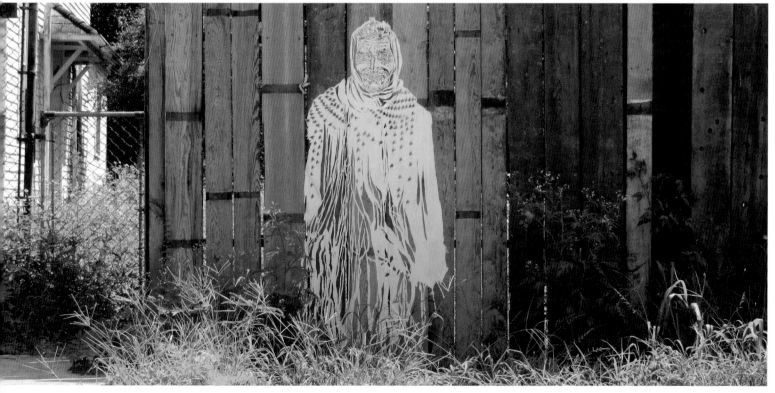

New Orleans, USA

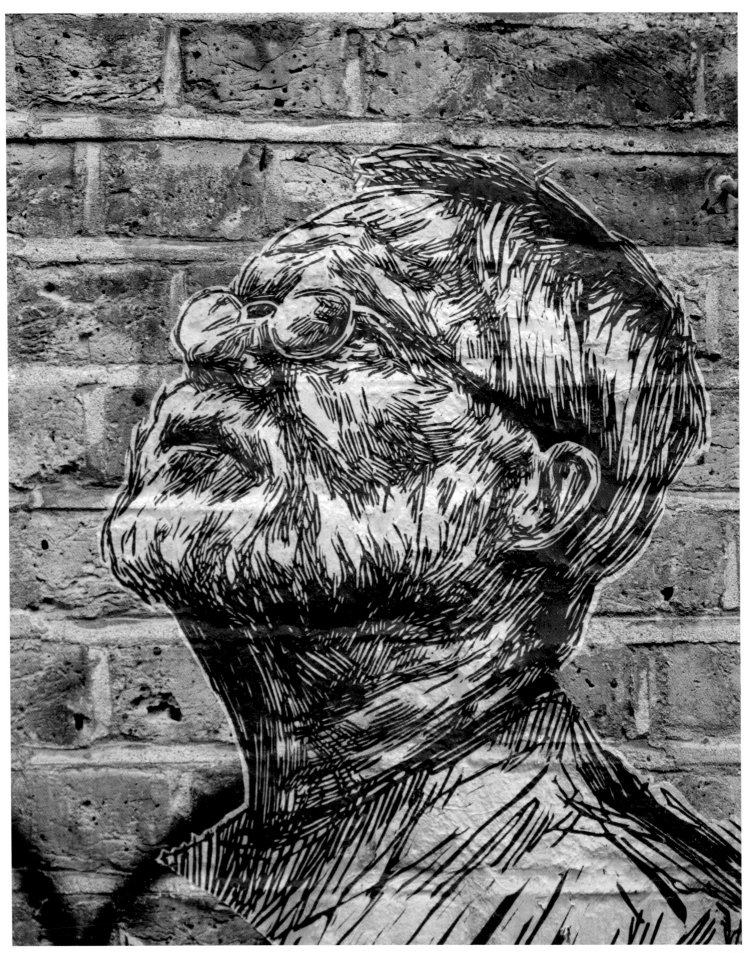

London, UK

EMA

from Paris, France

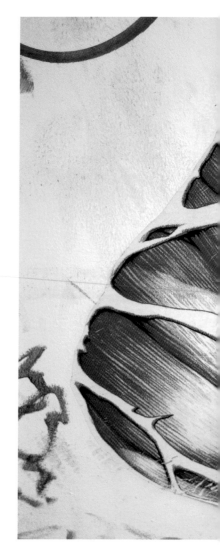

When EMA left France in 2001 to live in Brooklyn, she was one of the few prominent female street artists around. This biologist-turned-artist is fascinated by particle physics and the high-energy particle collisions that might be able to cause black holes. She developed figures that represent research scientist geeks, resplendent in hirsute elegance. While empty warehouses contain large-scale painted versions of her most recognizable character, Dropman, this cone-headed figure with well-groomed facial hair usually appears on droplets pasted on to doors and walls.

Returning to Europe in 2010, EMA found she had space to think away from the overcrowded street galleries of Williamsburg and began to screen print and paint on canvas again, exhibiting this work in UK galleries. She continues with her street art practice on a larger scale now, seeing little difference between abandoned buildings and the more traditional venues that show art.

Her most recent droplet work directly looks at the clash of particles, with battling characters below a power plant vying for domination.

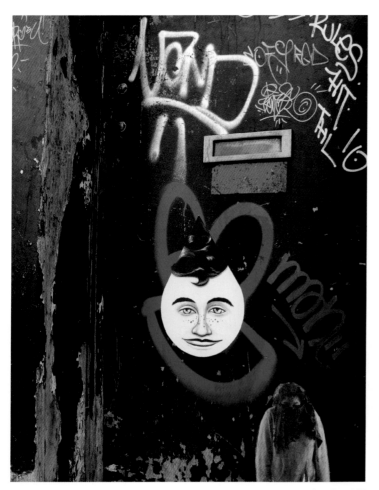

London, UK

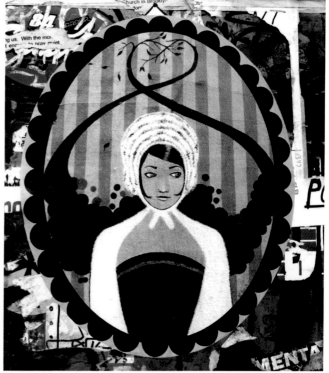

New York City, USA

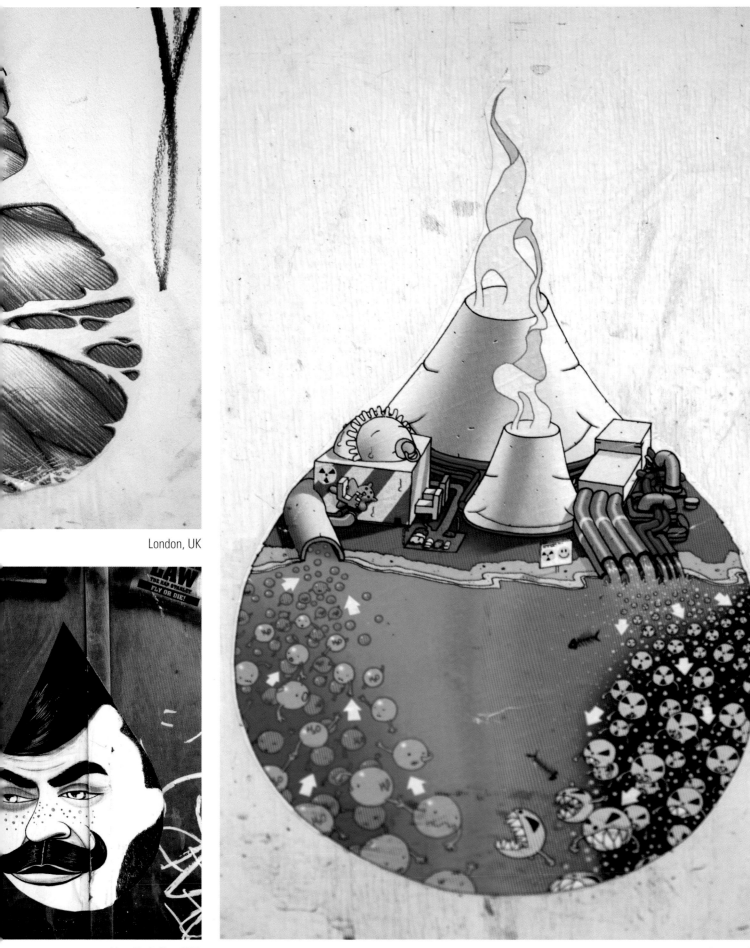

London, UK

New York City, USA

London, UK

London, UK

JR

from Paris, France

A photographic artist who has described himself as a 'photograffeur', JR takes images of ordinary people then pastes them up in printed sections to create huge monochrome posters. His work combines art and activism, reclaiming neighbourhoods from an advertising industry that dominates public spaces. Pasted-up paper on the scale of small posters occupies underpasses while the larger pieces can spread across a whole favela in Brazil or an office block in Manhattan.

JR has stated that the street is 'the largest art gallery in the world' and, after winning the *TED* (*Technology Entertainment and Design*) Prize for 2011, he ploughed the whole $100,000 awarded straight back into his ongoing projects. These include photographing residents and decorating nearby buildings with the resulting images. He has also hung massive portraits of both Israelis and Palestinians facing each other on either side of the Separation Barrier, in an attempt to use art to encourage each side to recognize the humanity of the other.

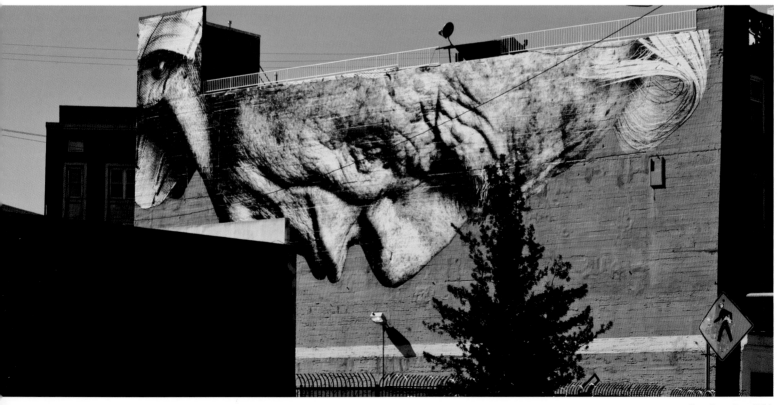

Los Angeles, USA

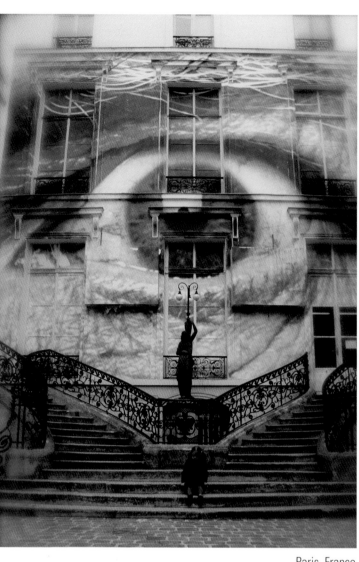

Paris, France

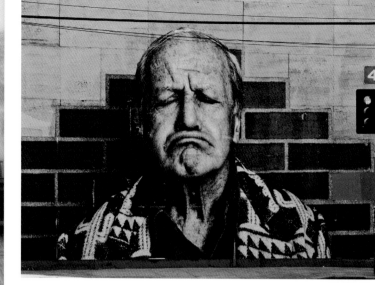

Los Angeles, USA

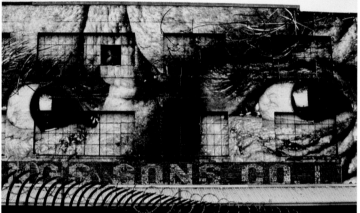

Los Angeles, USA

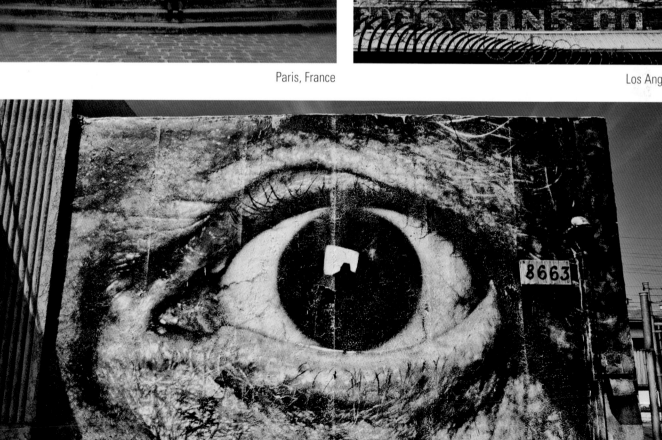

Los Angeles, USA

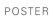

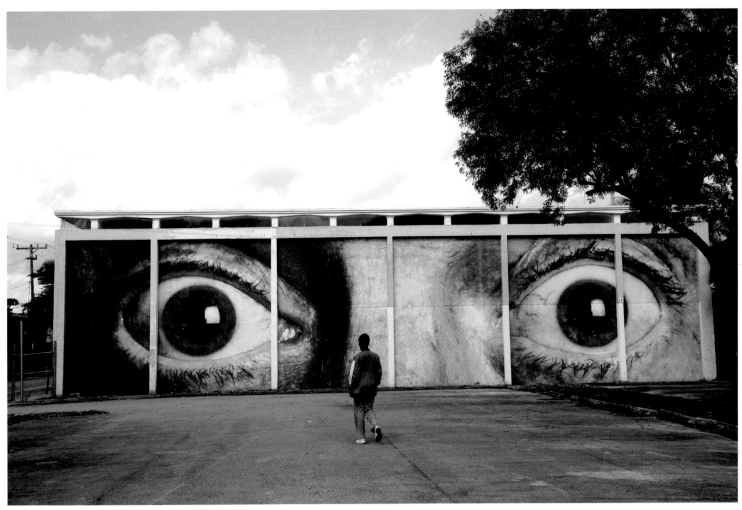

Miami, USA

New York City, USA

New York City, USA

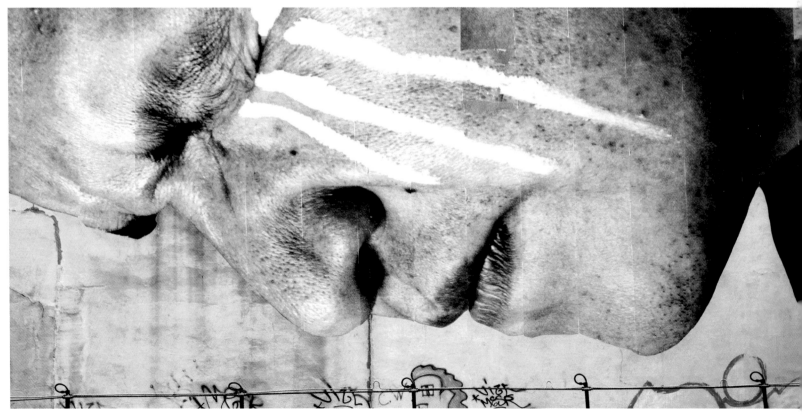

New York City, USA

ACE

from London, UK

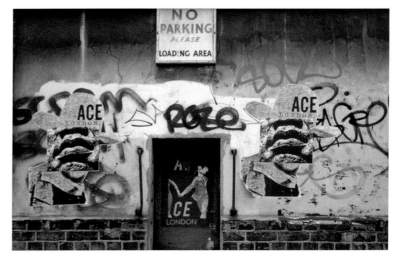

merging from the graphic style of skate culture, ACE has become London's most visible poster artist, with a proliferation of work that meshes cartoon characters, magazine cover stars and images of the post-war domestic ideal into a collage of overlaid popular culture. Techniques using screen printing and laser copying parody the mass-production of disposable printed media, and the placement of his work on the street references his original skating explorations of the city.

These posters often appear in clusters across various surfaces along a road that has industrial doors and recesses. This mimics advertising sites by using a scaled-down flyposting campaign that continues the DIY punk tradition, where music and fashion magazines, gigs and events were promoted outside the mainstream.

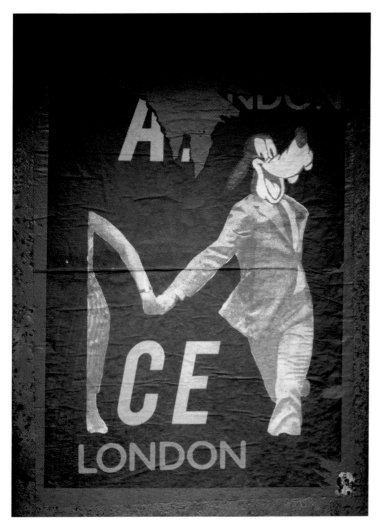

All images shown here are in London, UK

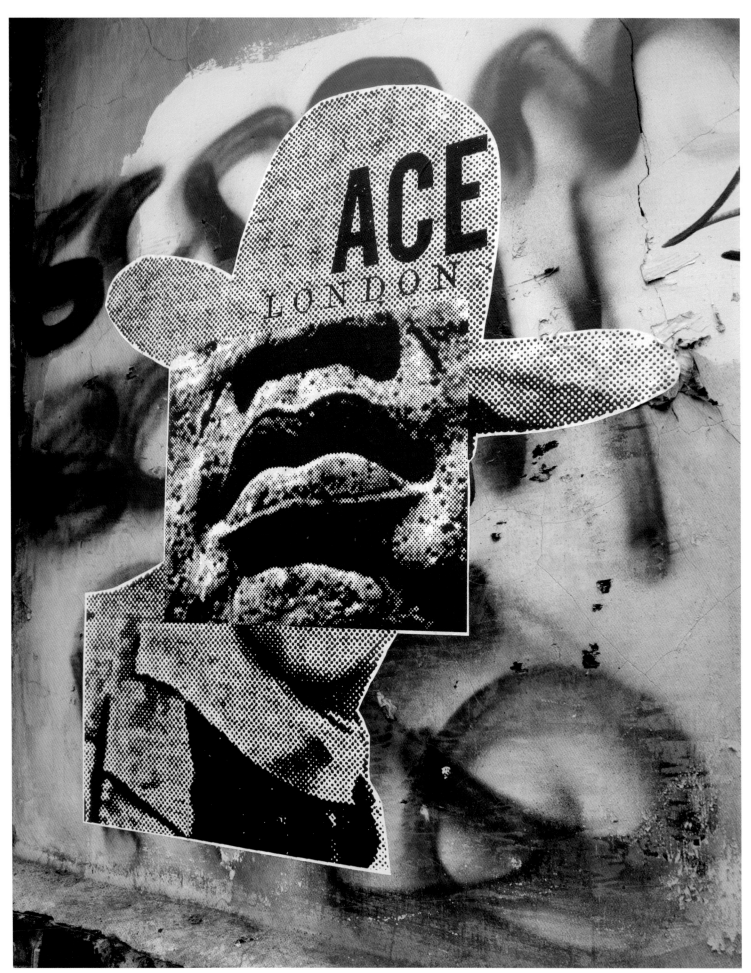

GAIA

from New York City, USA

This young artist examines the definition of a private and a public space by placing posters of his linocut portraits of notorious property developers on sites where residential blocks have been destroyed and then lie dormant for long periods. The separate paper elements of Gaia's work are often deliberately pasted up so they are not perfectly aligned, providing a commentary on the neglect of the site. His oeuvre also contains a menagerie of wild animals that occupy the city landscape, work that forms part of an emerging movement, instigated by Swoon, which Bushwick's Ad Hoc gallery director Andrew Ford describes as 'urban folk art.'

Unlike in other centres of excellence, New Yorkers respect crafted artwork in public spaces and usually leave it untouched. Although the NYPD Vandal Squad compiles files on perpetrators, much street art, dating back as far as the 1970s, still remains in place. This is one reason that Gaia likes to work in this city, as opposed to Chicago, for instance, where officials remove art regularly.

By its very location, street art becomes unconventional, perhaps even political, but ironically it also provides exposure for artists such as Gaia who wish to sell through traditional avenues and seek a balance between the gallery and the street.

Los Angeles, USA

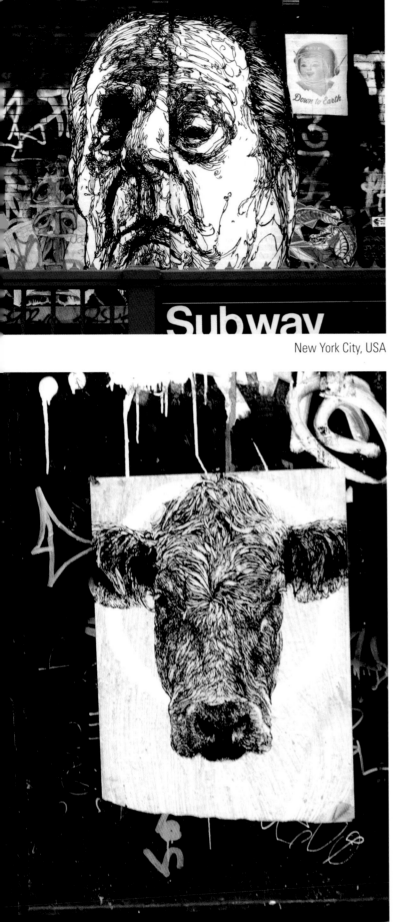

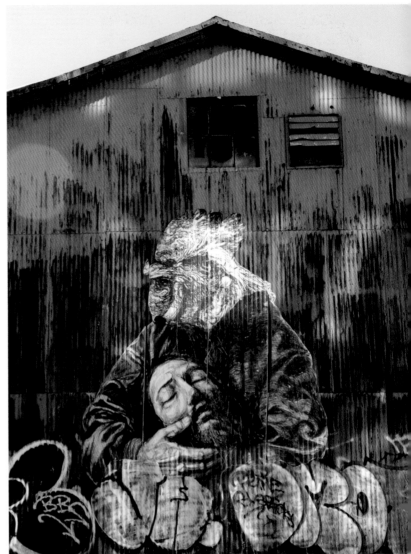

New York City, USA

New York City, USA

New York City, USA

Los Angeles, USA

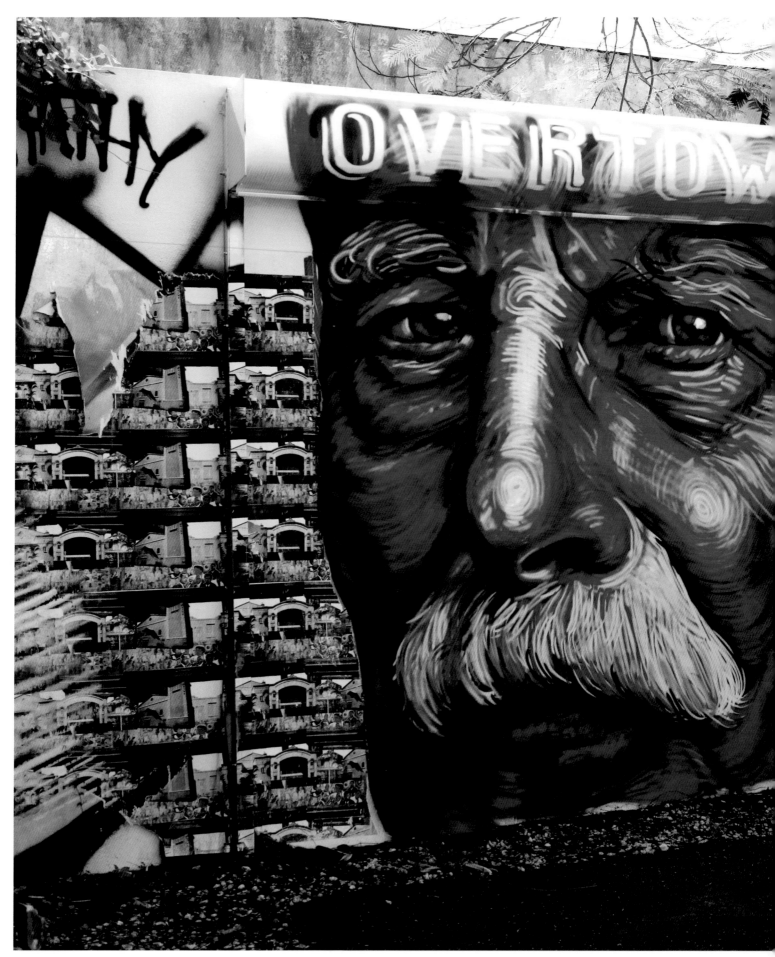

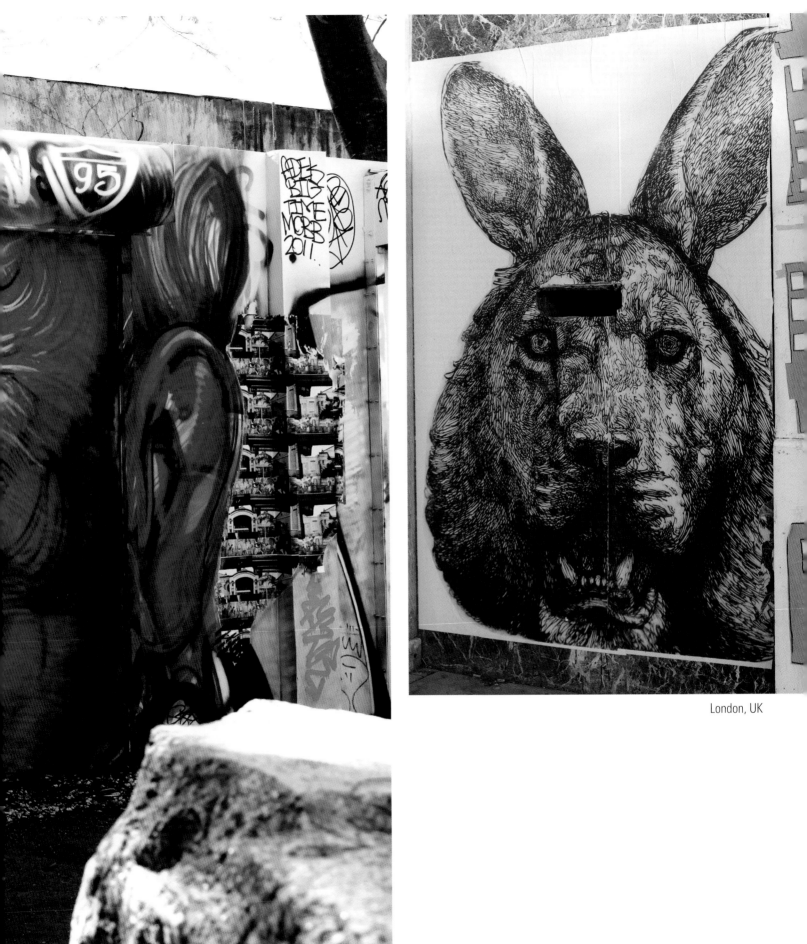

London, UK

Painted portrait over wheatpaste poster background, Miami, USA

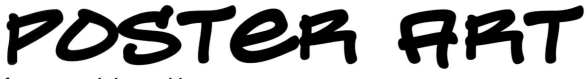

from around the world

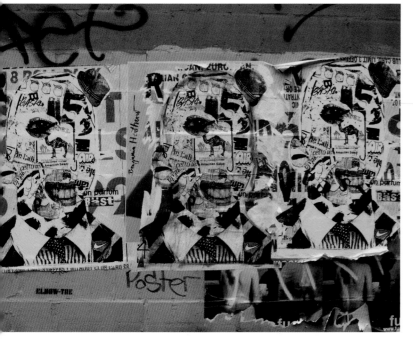

Bast, New York City, USA

Unknown artist, London, UK

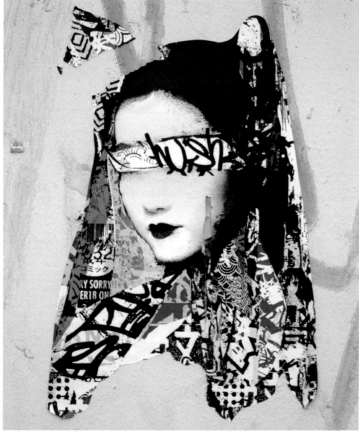

Hush, Newcastle, UK

Unknown artist, London, UK

Primo, EMA and Kid Acne, New York City, USA

Willow, New York City, USA

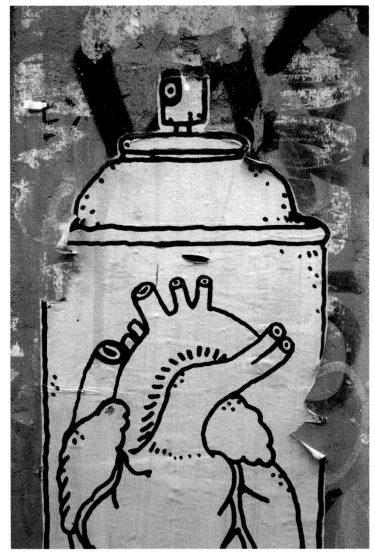

Unknown artist, London, UK

Unknown artist, London, UK

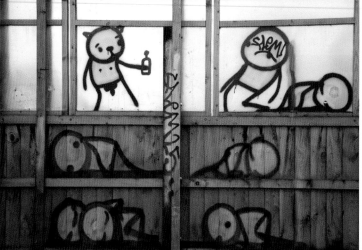

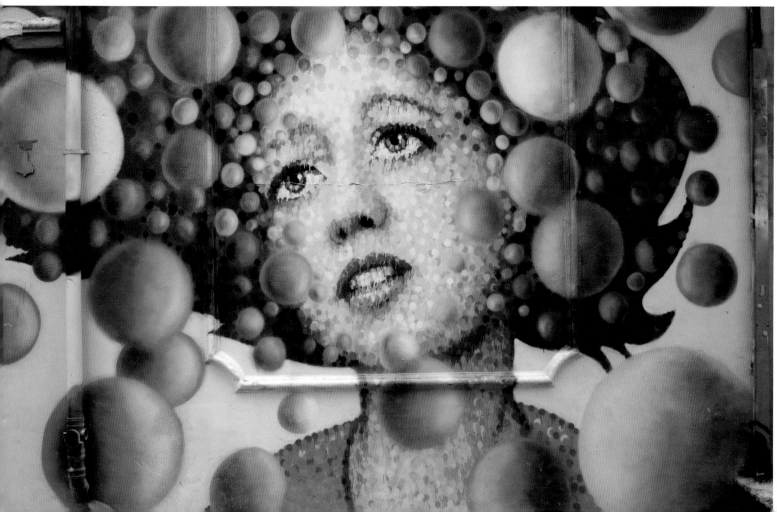

CHAPTER 3

BARRY McGEE

from Northern California, USA

This most versatile of street art practitioners is also known as Lydia Fong, Ray Fong, Bernon Vernon, P.Kin, Ray Virgil and Twist with further variations of the latter such as Twister, Twisty and Twisto.

After specializing in painting and print making at San Francisco Art Institute, McGee sought an antidote to the advertising that dominates the visual language of the urban American landscape. This involved creating sculptures using bottles left hanging on the street.

This elder statesman of urban expression art has become a mentor to many younger artists and even though his work is widely exhibited in major galleries around the world, declares himself happiest when working on the street.

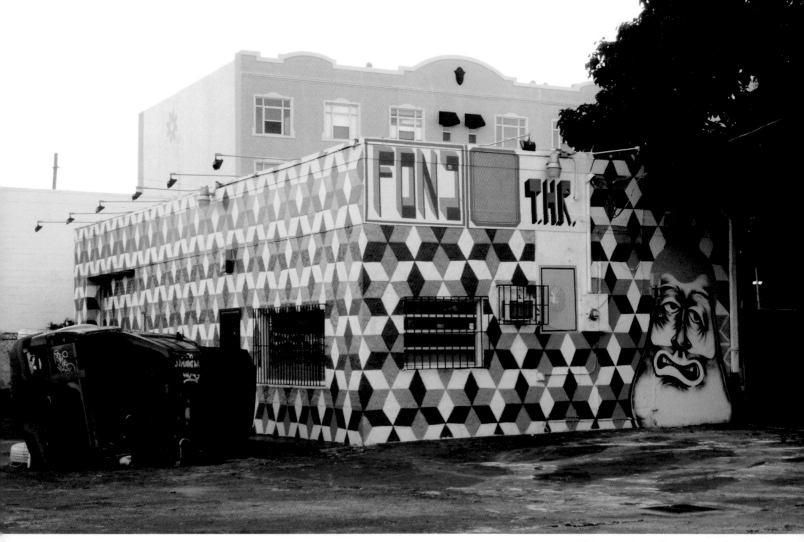

All images shown here are in Miami, USA

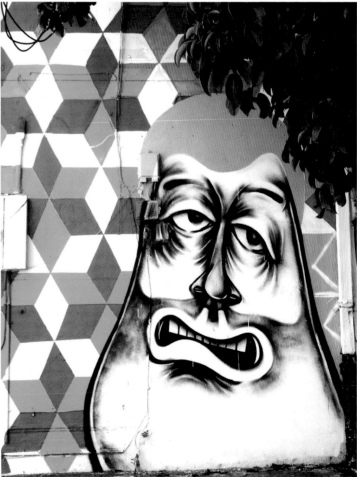

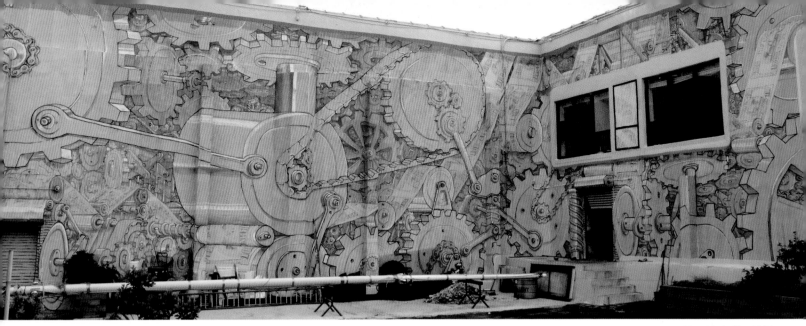

BLU

from Bologna, Italy

After ditching the spray can of his youth and moving on to household paint applied with rollers mounted on poles of adjustable lengths, this Italian artist literally made his mark, covering whole walls of multi-storey buildings.

His strong ideology of reclaiming public space through the application of murals has taken him across the globe. He likes to arrange his work so that invitations to festivals coincide with less official projects. These include producing work for people living in emerging states that are also trying to reoccupy land, such as the Miskito people of Managua, Nicaragua and the Palestinians in the West Bank.

While living in Argentina in 2007/8 he devoted most of this time to completing a multi-award winning stop-frame animation, *Muto* (Silent), which brings his process of painting to life. Within a breathtaking seven-minute sequence that has received over 10 million YouTube viewings, a trail of artwork follows the shapes of buildings in Buenos Aires, appearing to be created by invisible hands.

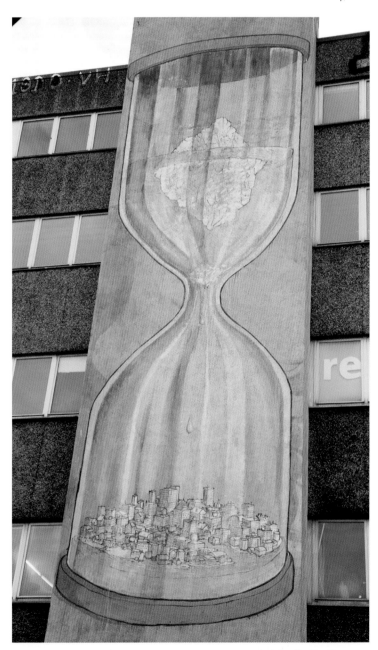

Berlin, Germany

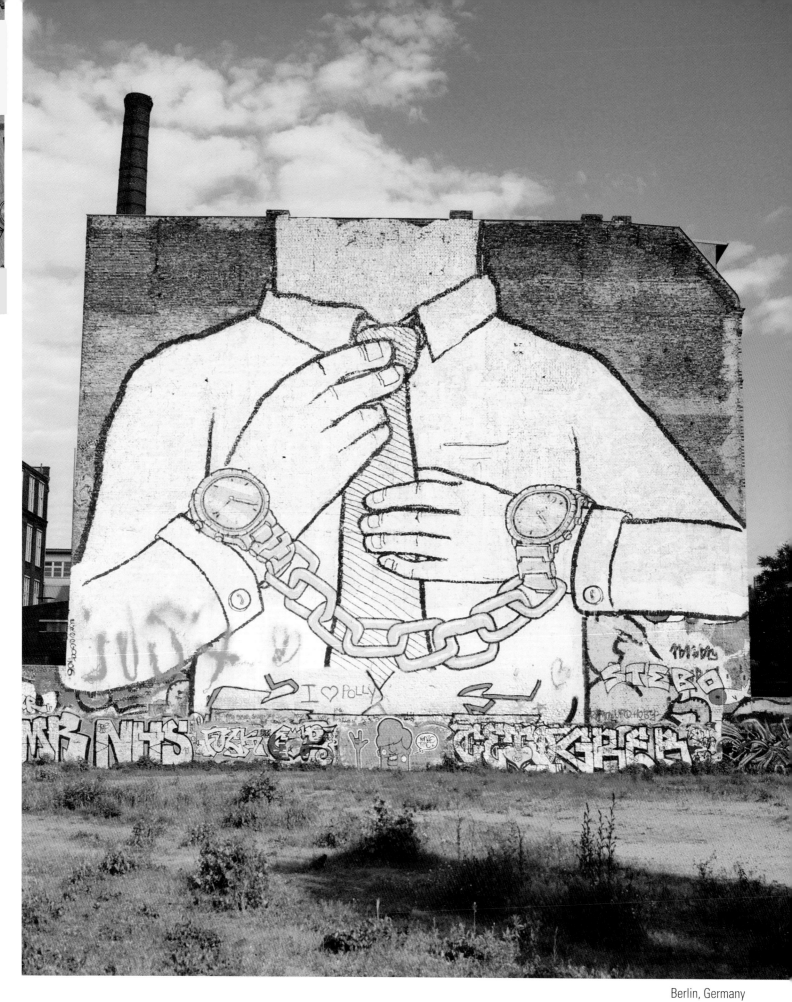

Berlin, Germany

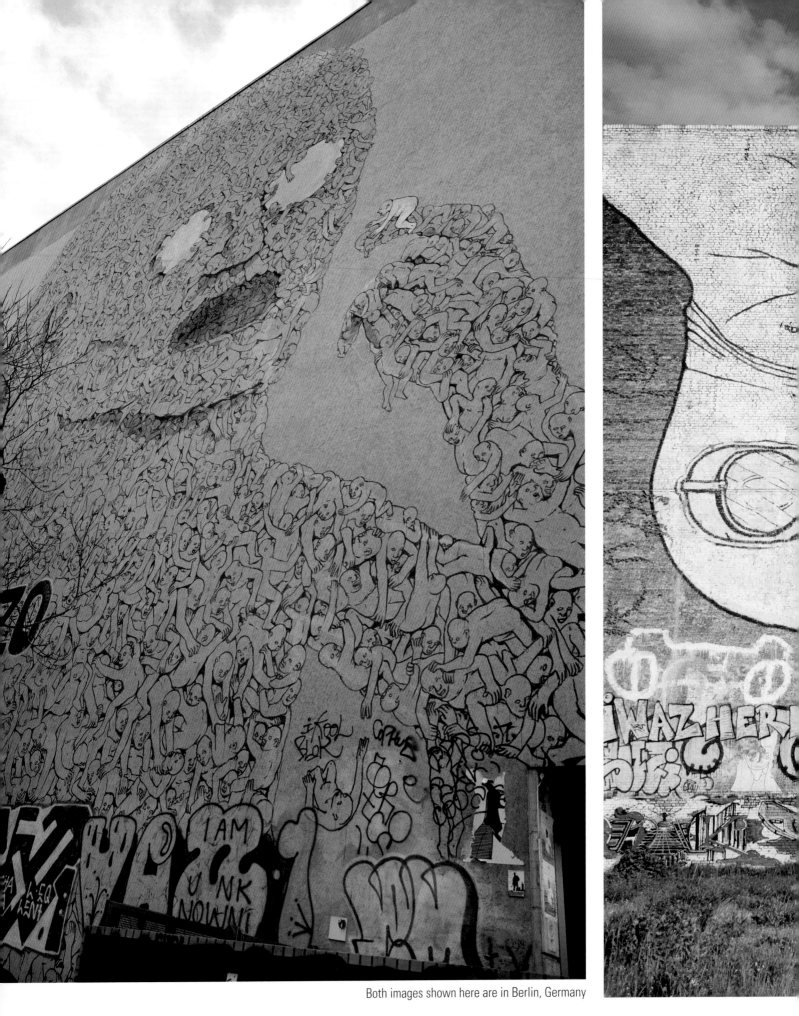

Both images shown here are in Berlin, Germany

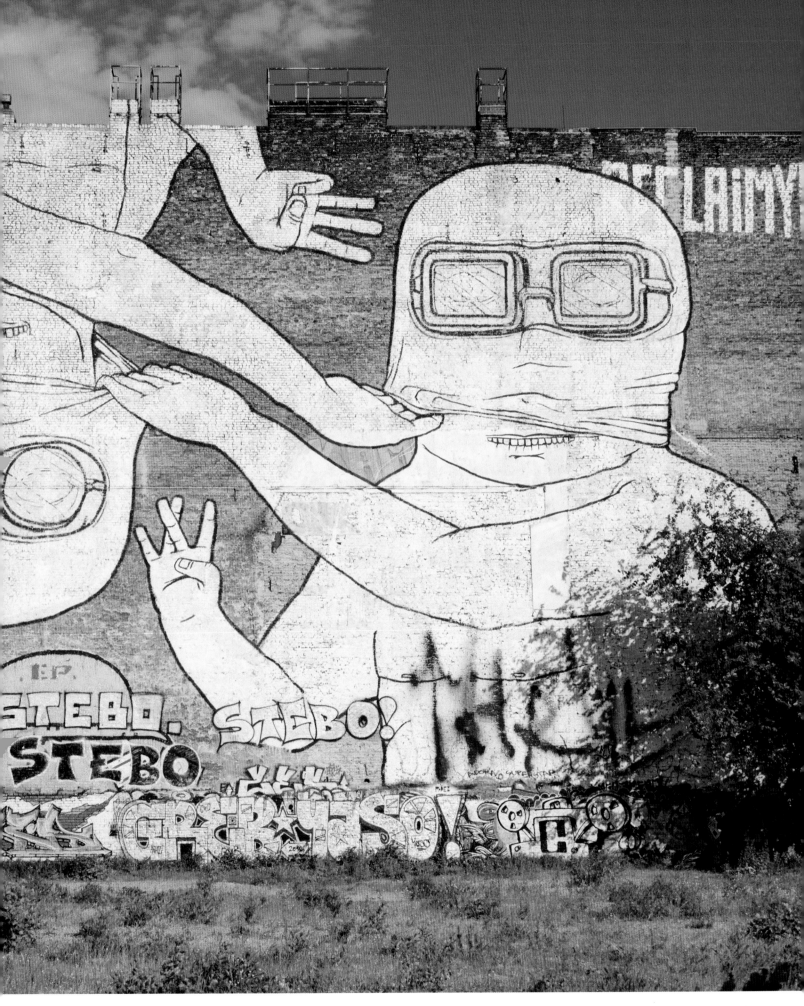

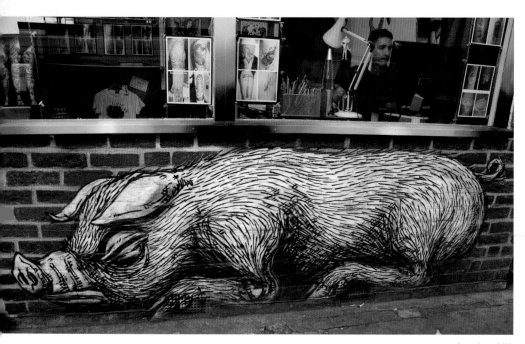

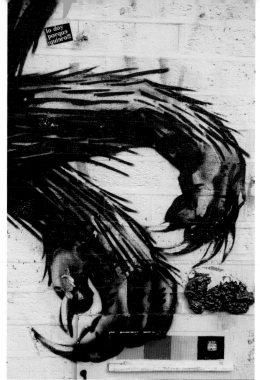

London, UK

London, UK

ROA

from Ghent, Belgium

This truly contemporary Flemish master celebrates the grace and mortality experienced by wild animals in the modern world, with meticulously fine line drawings that dominate the sides of buildings worldwide. Roa explains the attraction that street art has for him as: 'You don't do it for money nor for an institution, it's free expression and it liberates yourself [*sic*] creatively from a lot of restrictions.'

He meticulously plans outlines then paints over these sketches during the night, a way of working that requires agreement from the buildings' owners. This can facilitate the direct input of local people, as occurred when he was planning a piece showing a heron in Brick Lane, London. Having listened to comments from the local South Asian community about the cultural significance of a crane for them, the artwork was changed to feature their bird of preference.

These monochromatic monsters – which stand as sentinels, loom from car park walls or snooze by sidewalks – display a feral existence that city dwellers are utterly divorced from, perhaps prompting a recognition of the fact that we share this planet with many other species.

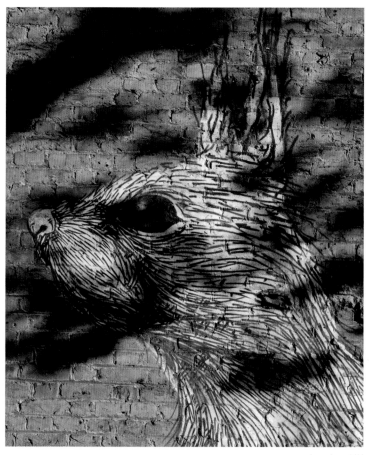

London, UK

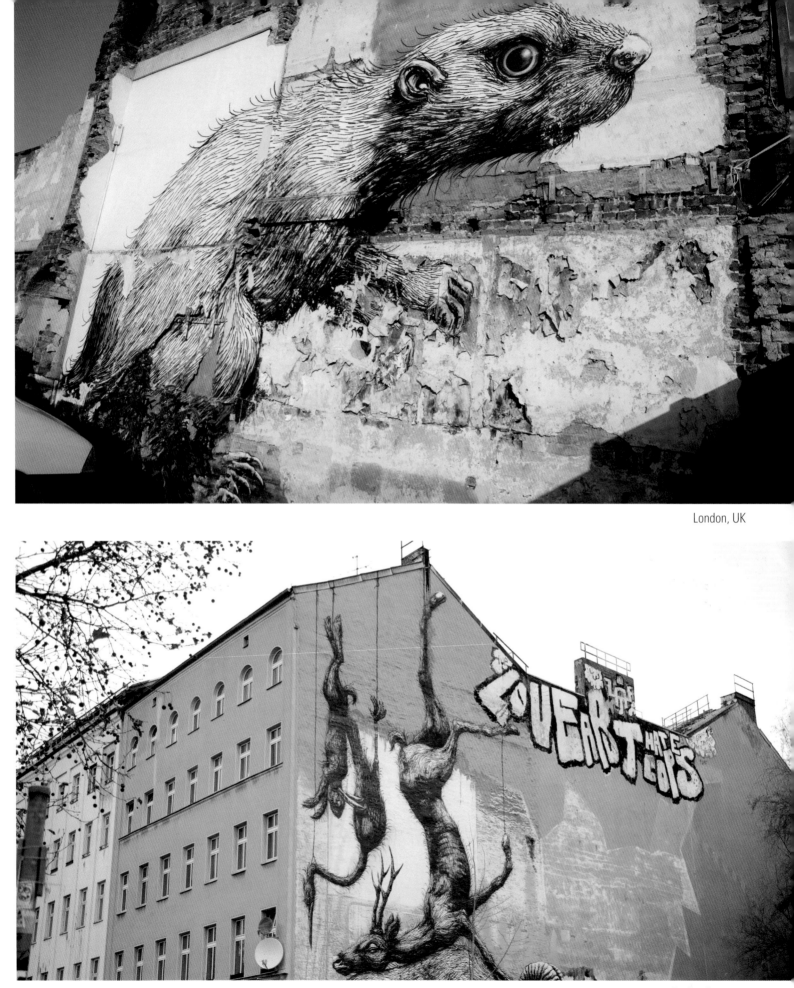

London, UK

Berlin, Germany

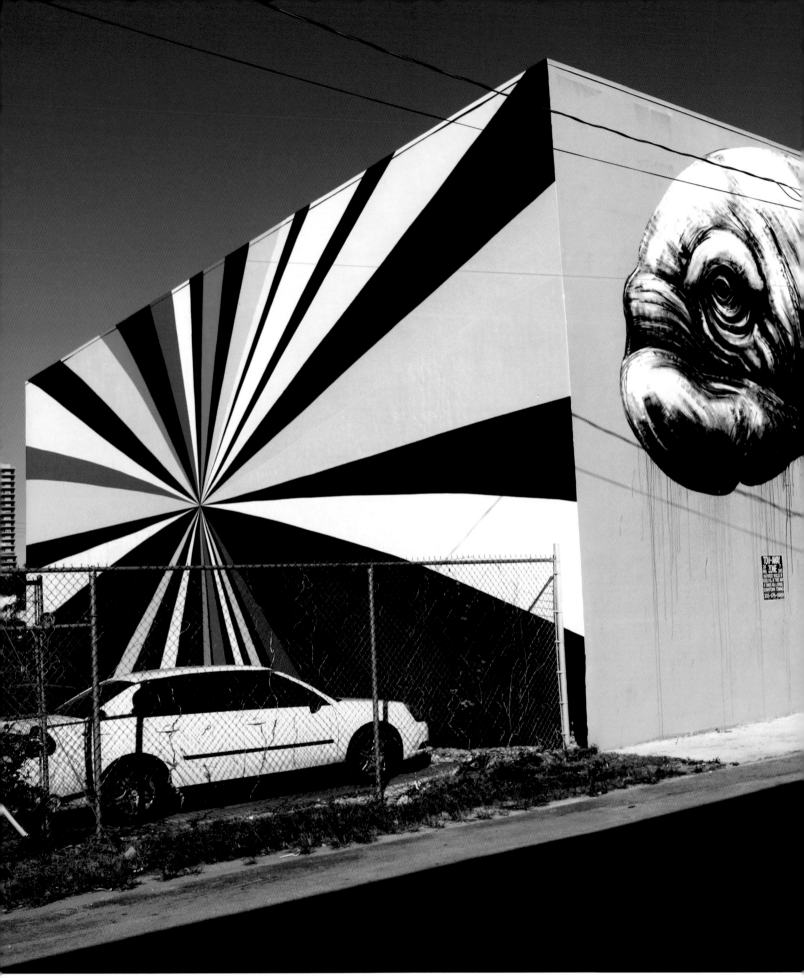

Roa on right-hand wall and Kenton Parker on left-hand wall. Miami, USA

London, UK

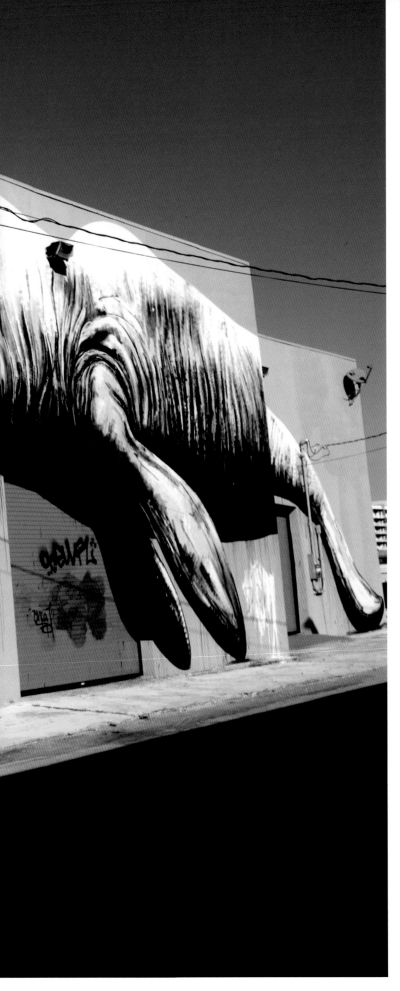

London, UK

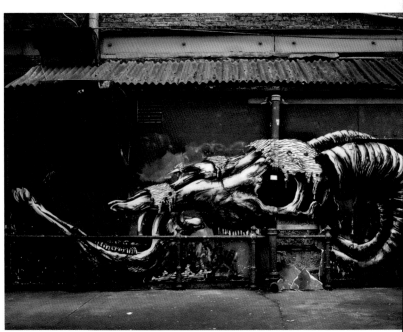

London, UK

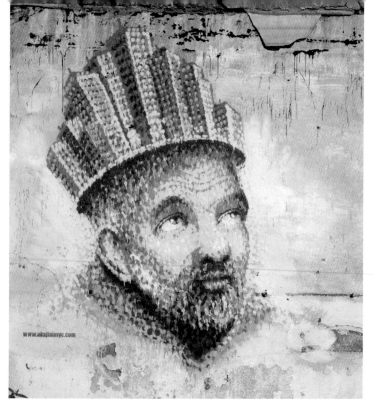

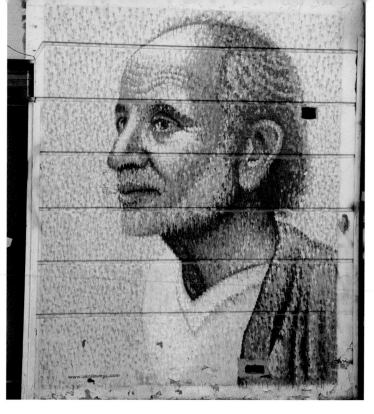

All images shown here are in London, UK

JIMMY C

from Adelaide, Australia

Influenced by the dot painting of Australian aboriginal communities, Jimmy C has been developing his own style since the age of 16, when he was living on the streets and expressing himself through graffiti.

He initially called his work 'aerosol pointillism'. The image is created by spraying small circles of paint on to a wall, and these form a portrait of someone he has met when viewed from a distance.

By letting the sprayed dots drip, he created his current style, which he calls his 'drip paintings'. These take up to three days to complete and involve the use of about 30 cans of variously coloured paints for each piece.

He has worked extensively in Paris and London, immersing himself in the lives of the homeless, where he carefully sketches from life before undertaking the final piece. Through these innovative applications and very intimate portraits, he has redefined the spray can medium as 'aero-soul' painting.

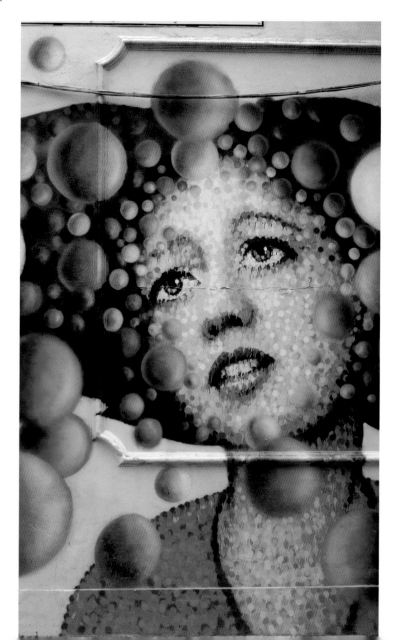

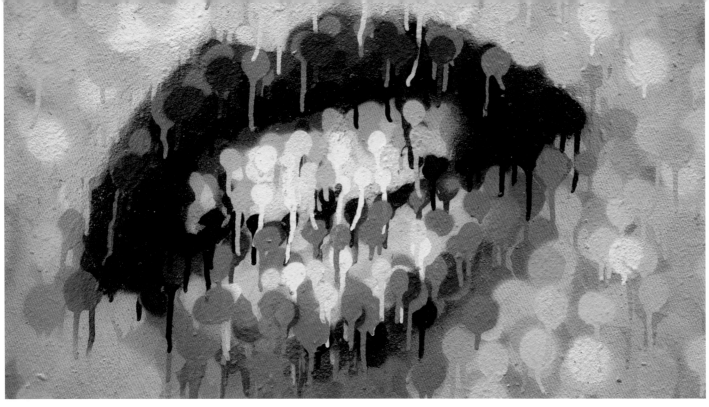

Detail of artwork on facing page (bottom right)

Detail of artwork on facing page (top right)

All images shown here are in London, UK

PHLEGM

from North Wales, UK

This Sheffield-based illustrator makes comics and paints on walls. His murals feature gothic characters who inhabit scenarios in the period between the Dark Ages and the Age of Enlightenment. The outdoor painted work parades across buildings and features a cast performing a succession of thankless tasks or searching for mythical beasts.

The figures can straddle large telescopes as they scan for a scientific breakthrough or be seen struggling under a medieval burden in an urban purgatory. Redolent of the fantastic mindscapes of Hieronymus Bosch or the wild imaginings of Edgar Allan Poe in stories such as *The Pit and the Pendulum*, Phlegm shares his expansive monochrome world on the public arena of the city wall.

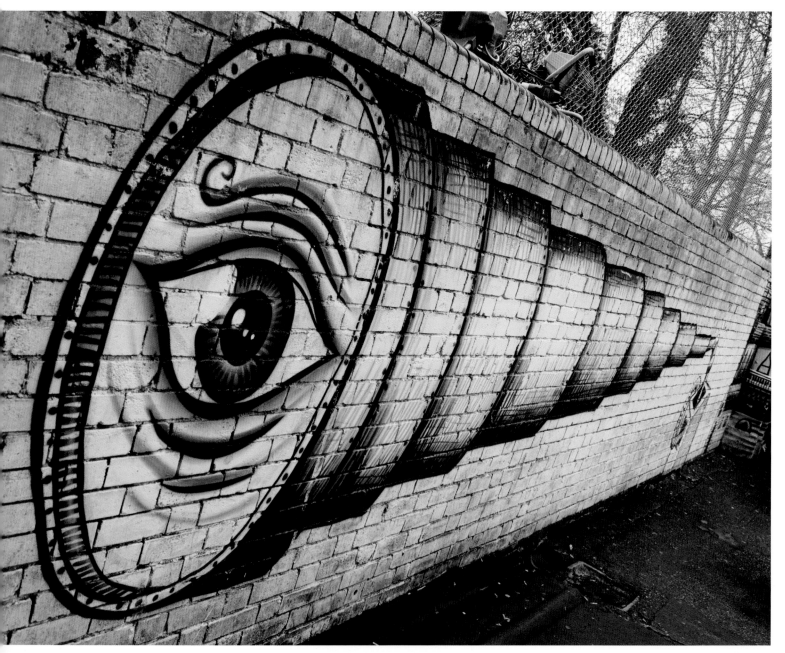

London, UK

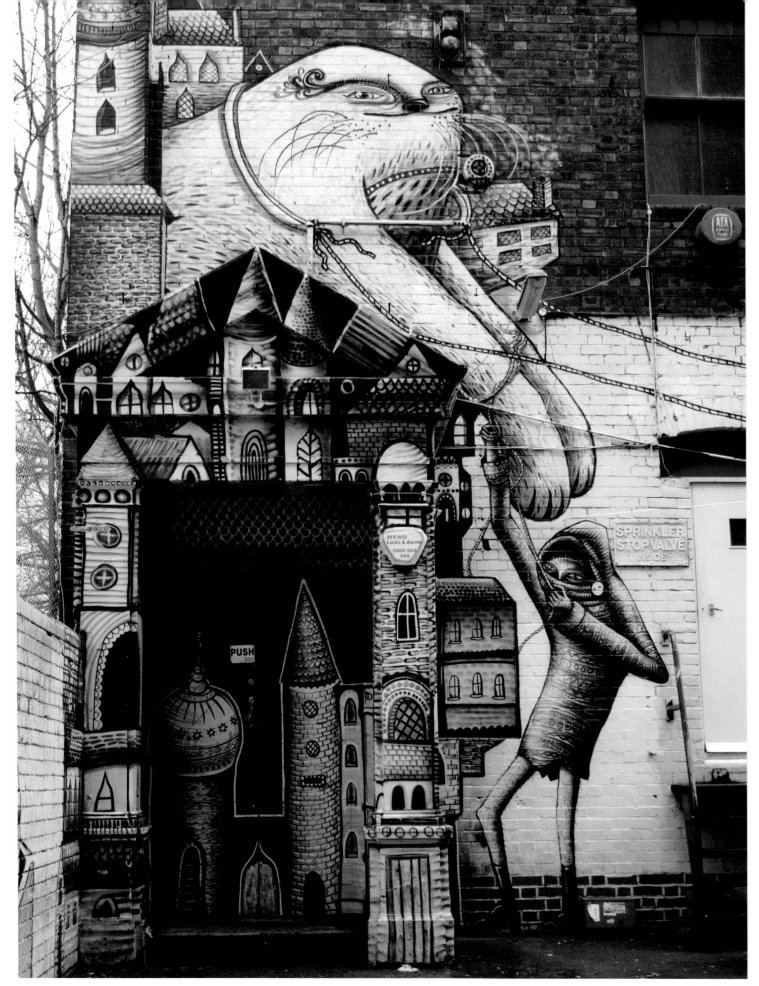

London , UK

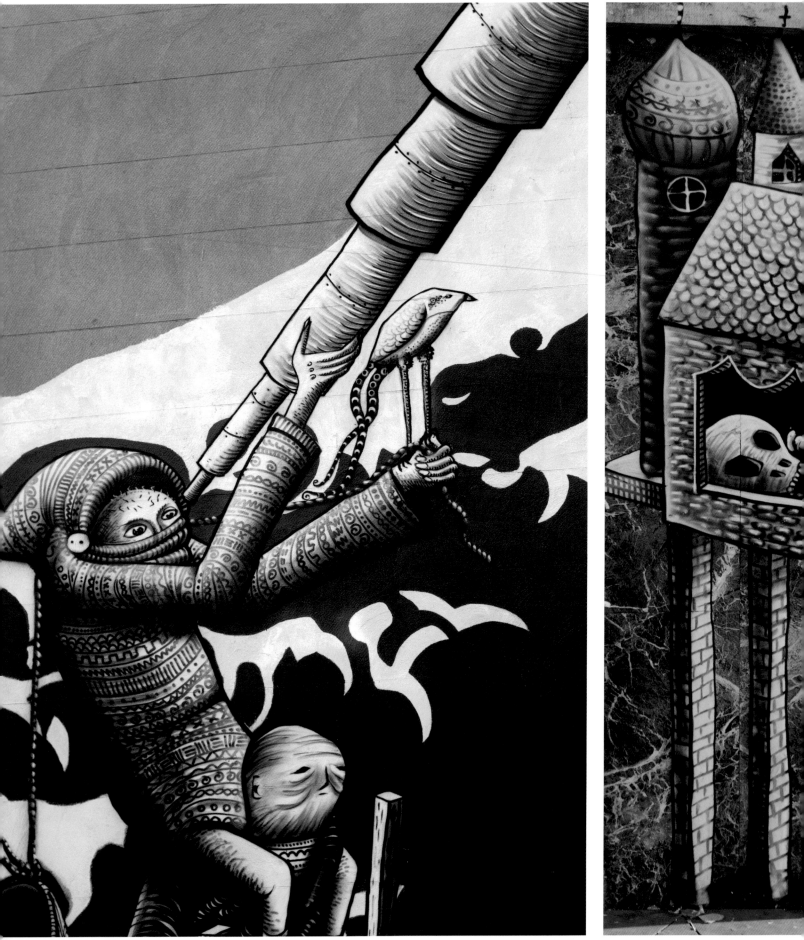

Bristol, UK

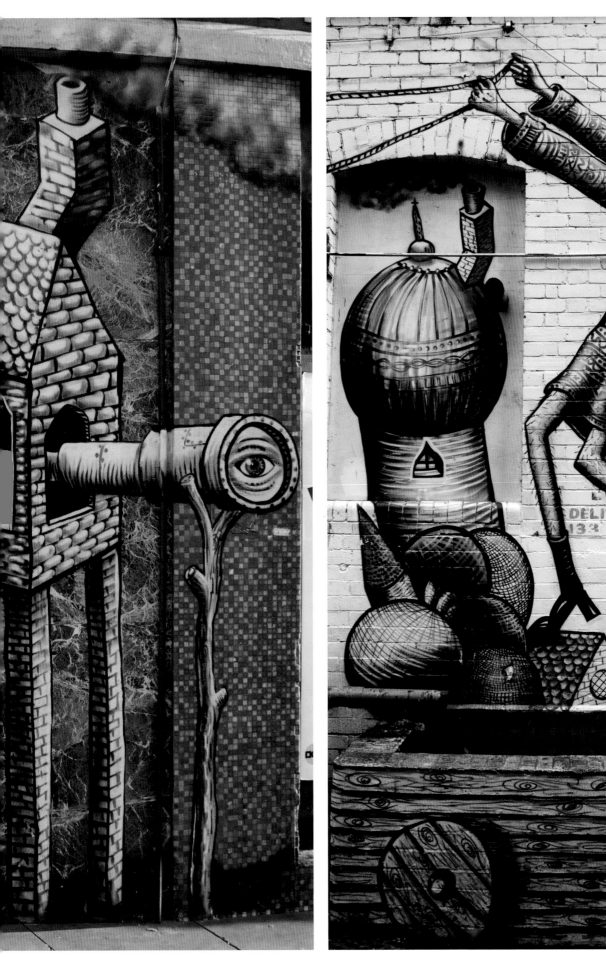

London, UK

London, UK

STIK

from London, UK

ne of the more locally based street artists, Stik started painting his tall, thin figures around Hackney in East London before moving to the more central location of Shoreditch. These largely androgynous characters display universal visual signs of human frailty and the vulnerability that can be brought about by unexpected changes in an individual's circumstances.

His unmistakable stripped-down, modern style recalls the BBC children's animation series *Bod* and the figurative exaggerations in L.S. Lowry's depictions of 'matchstick men' in his paintings of the industrial regions of Northern England in the early 20th century.

Stik was homeless for a period and this experience often influences the moods of the figures, although they can also be playful or mischievous. He is known to sometimes remove panels and tuck smaller Stikman sections under the arms of nearby and larger Stikmen as a comment on the theft of street art following its rise in monetary value.

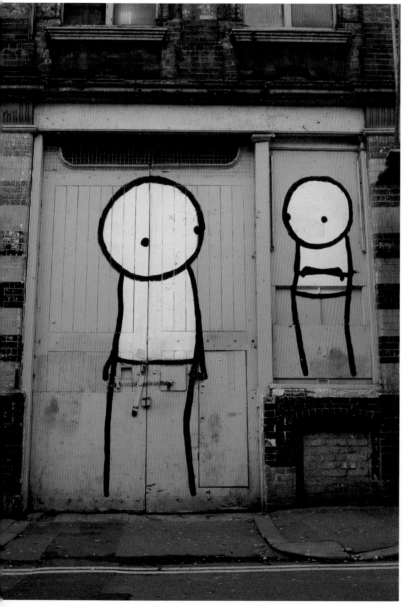

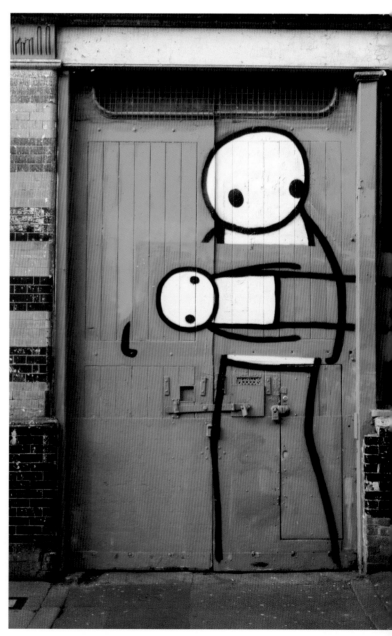

All images shown here are in London, UK

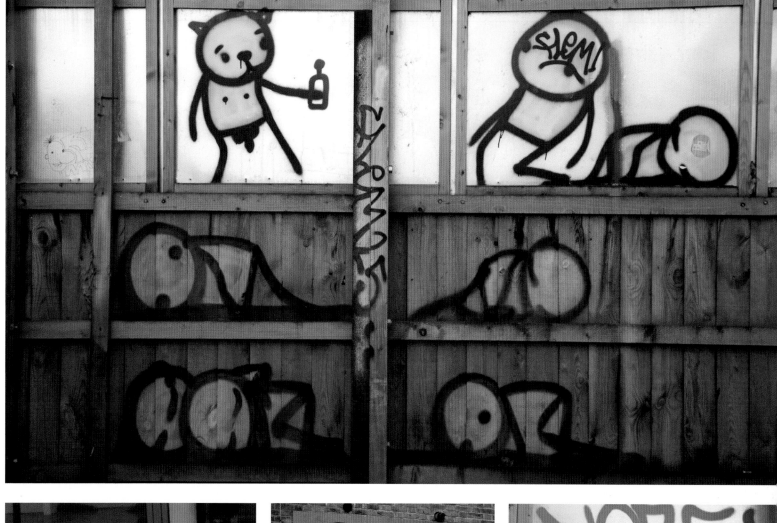

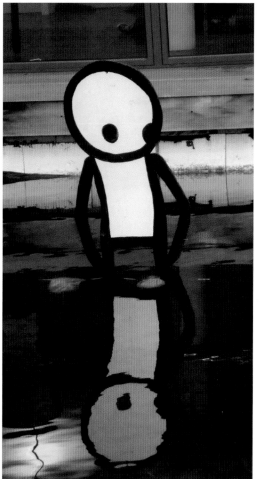
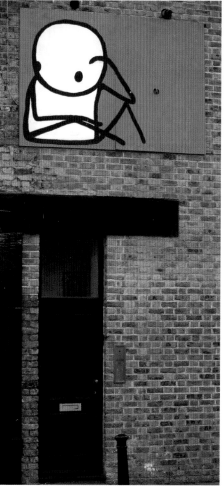

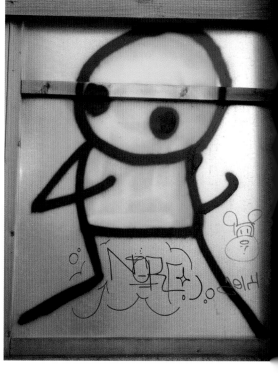

eINe

from London, UK

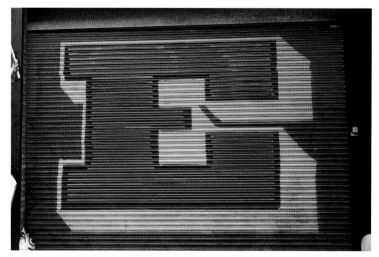

London, UK

Metal window shutters are the first choice of surface for Eine, who produces work that is hidden when the shops are open. Eine paints the acceptable typeface of street art, and completed a full English language alphabet along Middlesex Street in East London in 2010. Shortly before this, one of his print pieces was given to US President Barack Obama by the British Prime Minister, bringing street art into international relations and the very epicentre of the Establishment.

Eine's lettering has been featured in many commercial commissions, being used by pop group Alphabeat and appearing in music videos for Snow Patrol and Duffy. In 2011 he was asked to produce the 50th anniversary poster for Amnesty International. This trend of supporting charity through the production of art is a tradition that has included artists such as Miró and Picasso.

Working from his studio in Hastings on the English south coast, Eine produces canvases and screen prints, and also finds time to travel the world painting brightly coloured texts on shutters and walls.

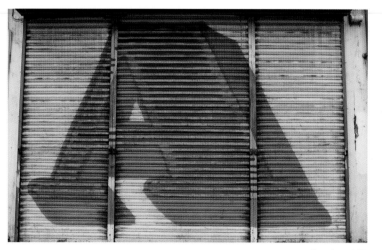

London, UK

London, UK

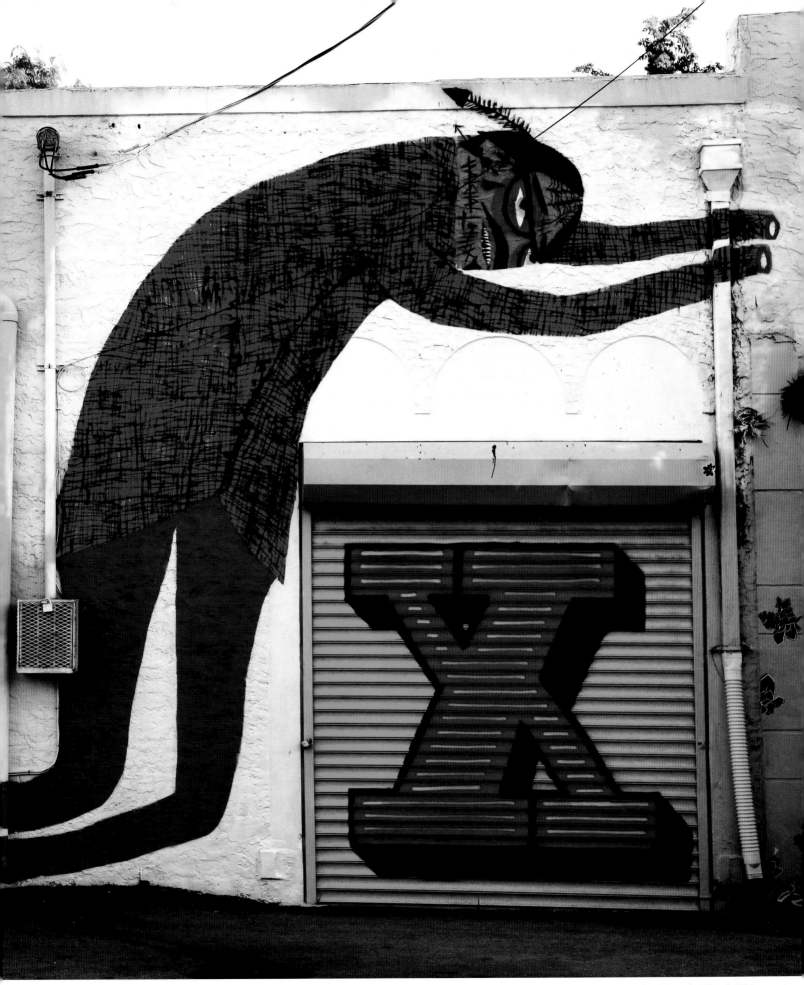

Eine and Spencer Keeton (red figure). Miami, USA

BMD

from Auckland, New Zealand

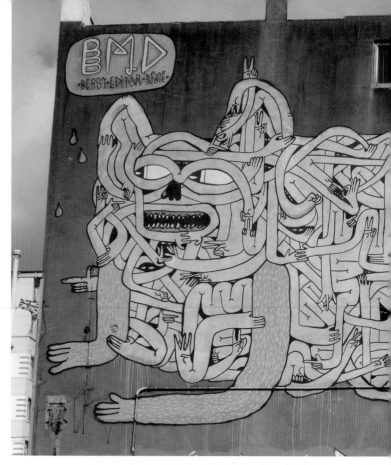

Corporate-savvy BMD have tapped into the current trend for street art and present themselves as a brand, which some could argue goes against the original ethos of the art form. However, the quality of their visual execution is in no doubt, and features engaging Keith Haring-esque collages of body parts, both human and animalistic. These figures are sometimes neatly sliced, directly responding to the architectural design of particular gable ends where disrupting angles offer the opportunity for an elongated polyptych.

This enigmatic Kiwi duo experiment in the science of 'bombing', while maintaining an extremely low profile, battling with music promoters for space on the areas around EoC (East of Cuba Street) in New Zealand's capital city, Wellington. This area was designated a street art space in order to provide a solution to the problem of spray can vandalism. An idea formed between local business owners and professional muralists, the area now creates a positive cultural impact and enhances the locality. The carefully planned image-based work epitomized by BMD seeks to offer enjoyment to all, in contrast with the rushed tag that only serves to codify the identity of the writer.

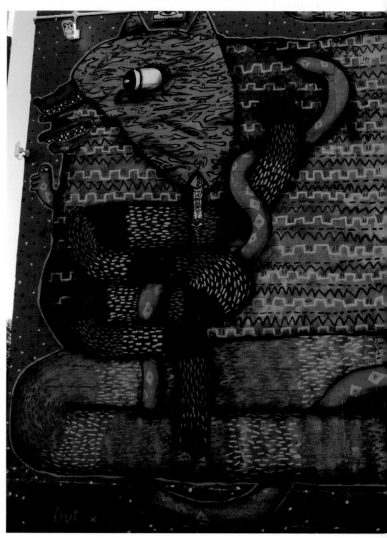

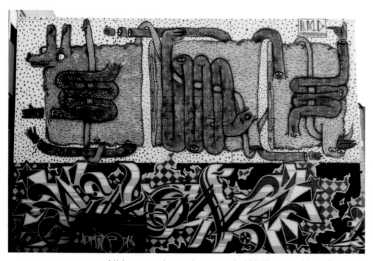

All images shown here are in Wellington, New Zealand

82

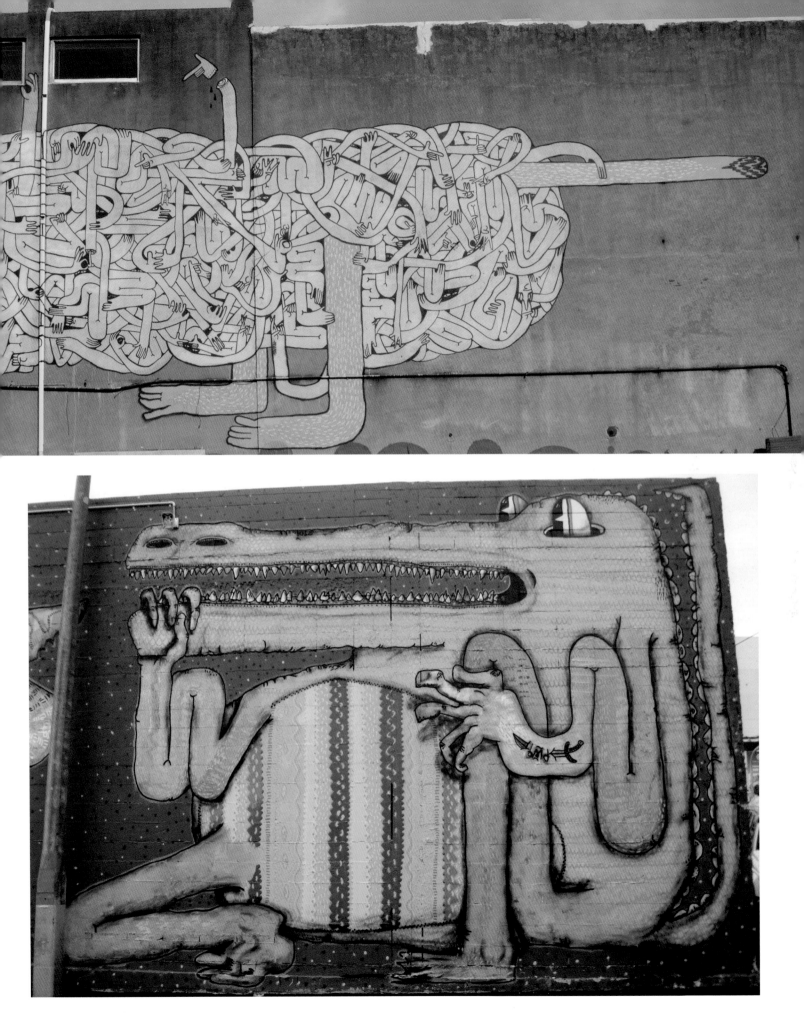

OS GEMEOS

from São Paulo, Brazil

Meaning 'the twins' in Portuguese, Os Gêmeos are a graffiti artist duo of identical boys who have been hugely influential pioneers in the development of Brazilian street art since the late 1980s, when the culture of hip hop reached São Paulo and the brothers got into breakdancing. This led on to related experiments with New York-style graffiti, collecting more localized influences along the way, including national folklore and Pixação ('wall writings') dating from 1940s Brazil.

Their style has developed into instantly recognizable brightly painted giant characters that look down from buildings in São Paulo and across the USA and Europe, epitomizing Brazilian street art worldwide. Whether family portraits or images revealing a deeper social commentary, the figures always have yellow skin. The brothers have admitted that they cannot bring themselves to paint flesh in any other colour – a tendency that is perhaps an assertion of the pride Brazil's multi-ethnic communities take in their identities.

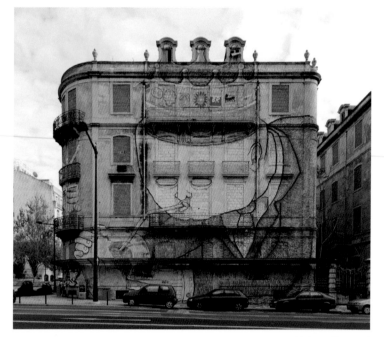

Lisbon, Portugal

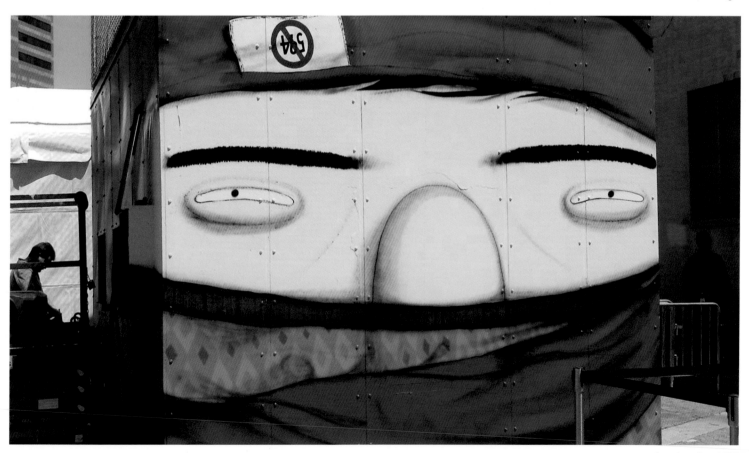

Los Angeles, USA

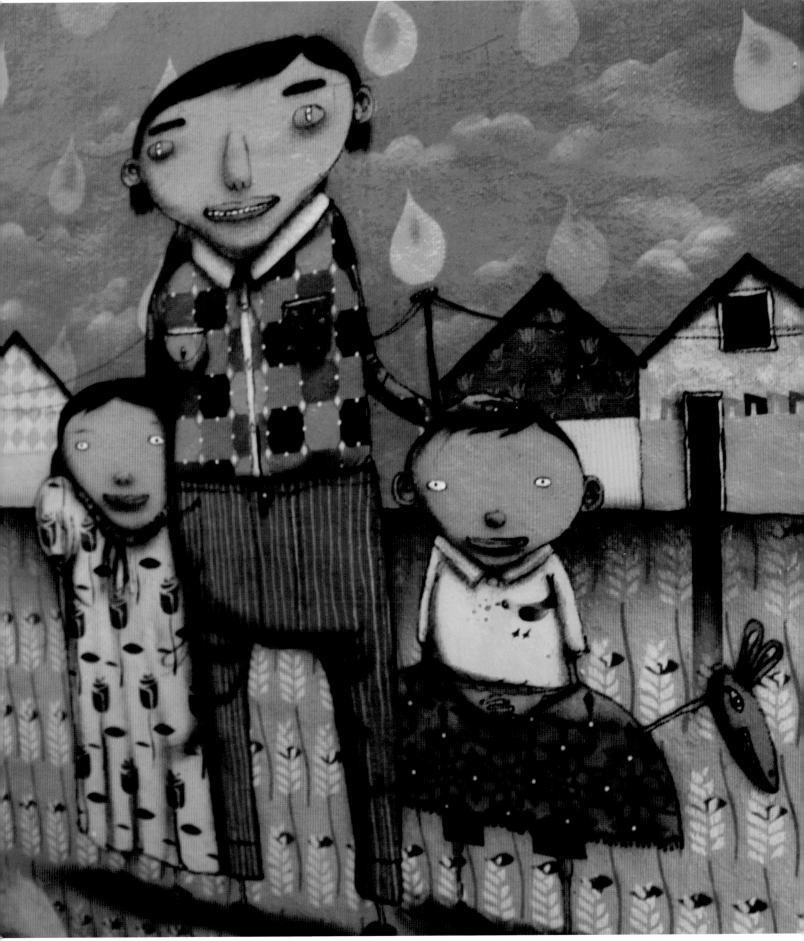

Miami, USA

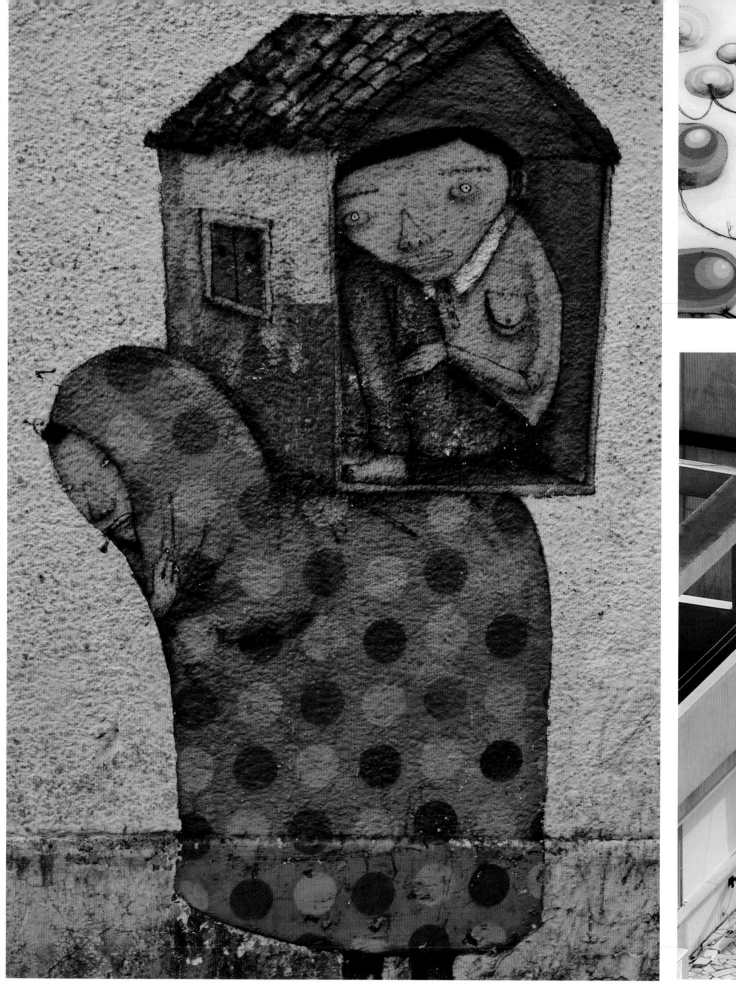

São Paulo, Brazil

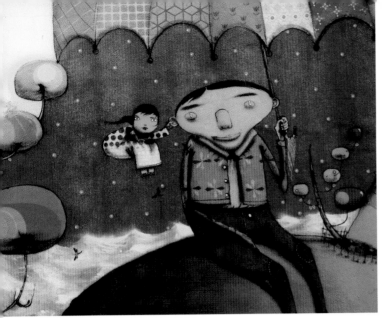

Miami, USA

Miami, USA

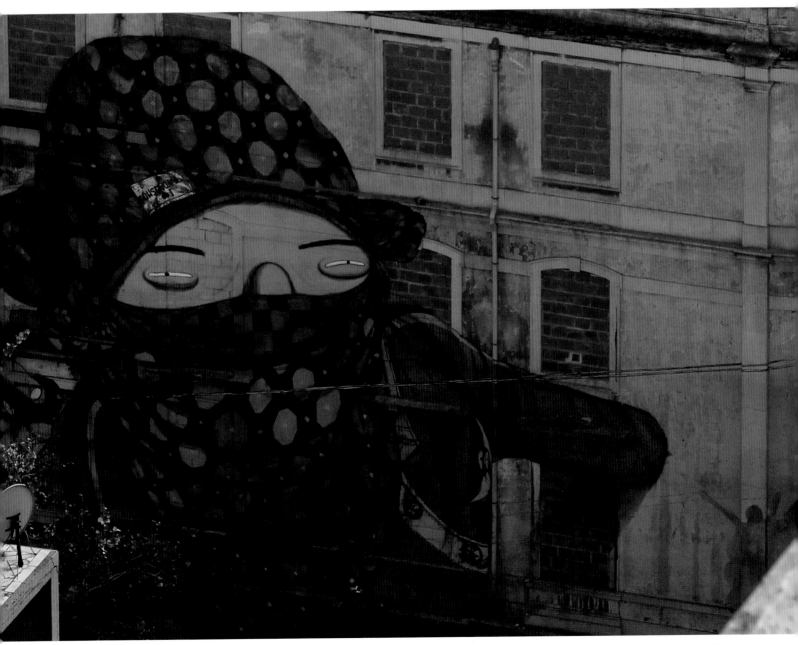

Lisbon, Portugal

PAINT ART

from around the world

Unknown artist, Rio de Janeiro, Brazil

Unknown artist, Rome, Italy

Unknown artists, Kuala Lumpur, Malaysia

Unknown artist, Rome Italy

Unknown artists, Ibiza, Spain

Cassette Lord, Brighton, UK

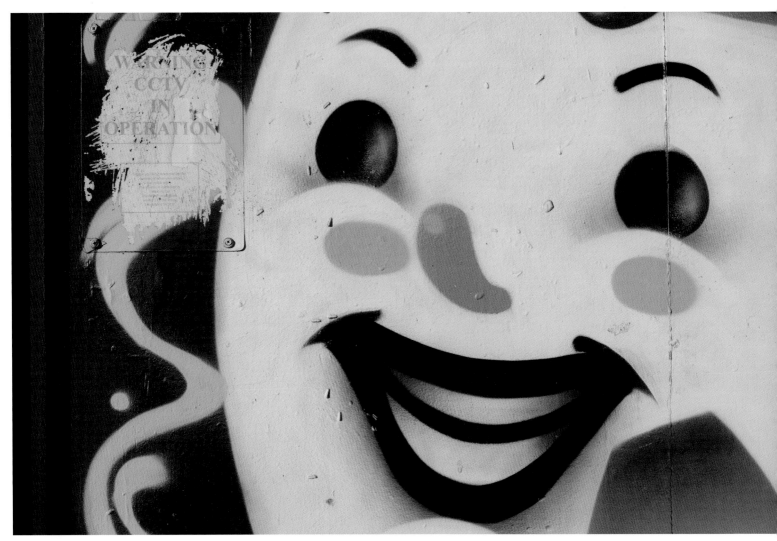

Unknown artist, London, UK

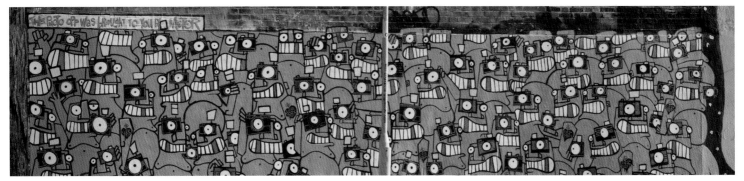

Motor, London, UK

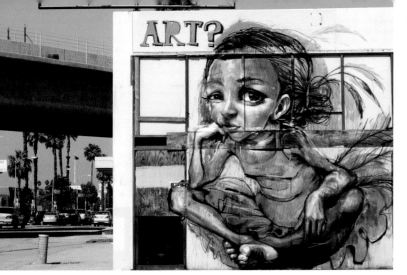

Herakut, Los Angeles, USA

Unknown artist, London, UK

David Walker, London, UK

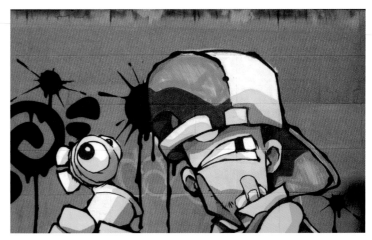

Unknown artist, Bristol, UK

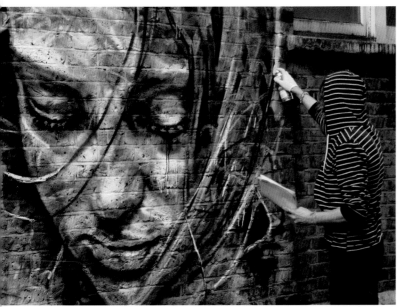

David Walker at work, London, UK

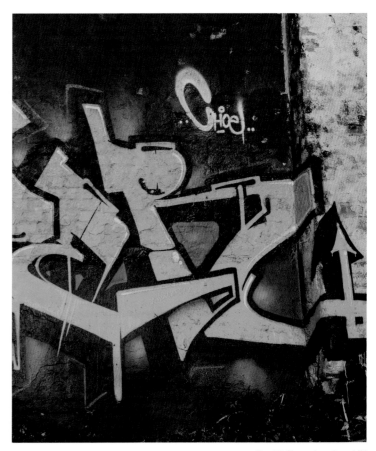

David Choe, London, UK

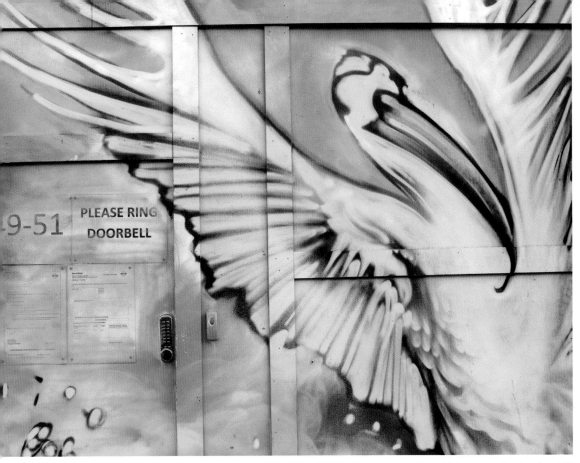

Unknown artist, London, UK

Sweet Toof/Mighty Mo, London, UK

Malarky, London, UK

Toasters, London, UK

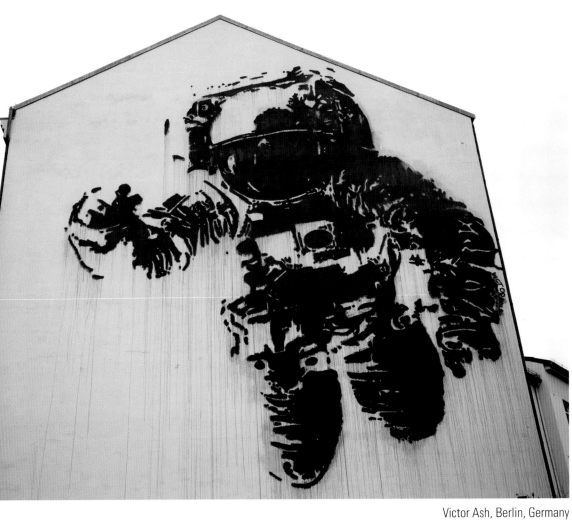

Victor Ash, Berlin, Germany

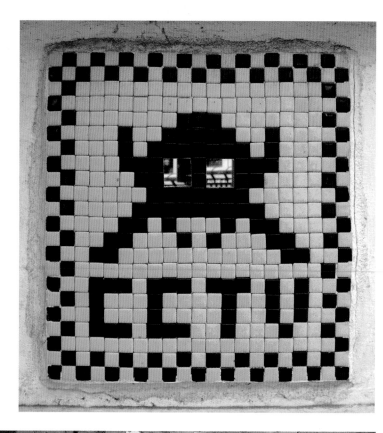

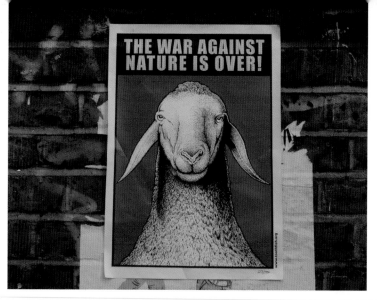

THE WAR AGAINST
NATURE IS OVER!

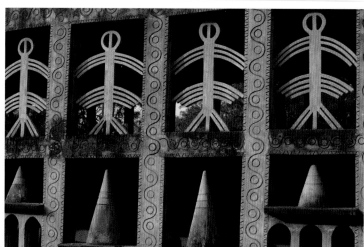

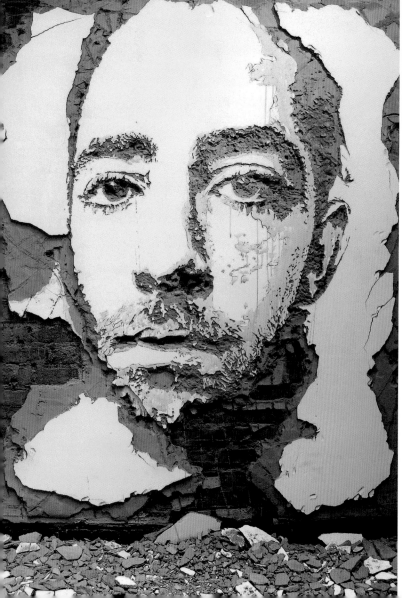

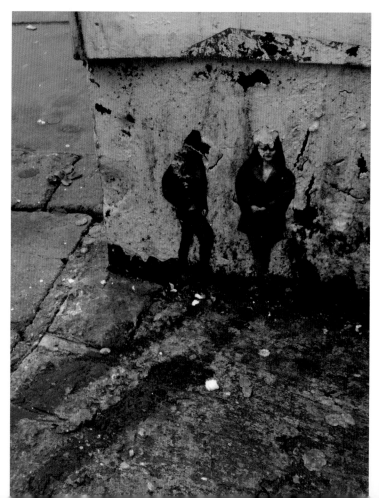

3D, MINIATURE AND OTHER MEDIA

INVADER

from Paris, France

The inclusion of a self-referential paint roller or spray can in Invader's more recent work is a sharp observation on most other street artists' methods, as this French artist uses ceramic tiles to construct his nostalgic gaming icons, not paint.

Hugely pixelated aliens were the screen anti-heroes of arcade video games such as Space Invaders that originated in Japan in the late 1970s. The use of ceramic tiles to recreate enlarged versions of these icons provides a commentary on our surveillance society and the occupation of public spaces. The extreme pixelation references methods used by the media to disguise car registration plates and faces in order to protect the rights of individuals in factual television programmes.

This artist first 'invaded' Paris in 1998, spreading to over 30 other French cities before crossing international borders into Australia, Austria, Canada, India, Italy, Germany, Japan, Kenya, Nepal, the Netherlands, Spain, Switzerland, the UK and the USA.

As these gaming images were created using very low-resolution graphics, they are perfectly suited for transmutation into small mosaics. Most often placed high up on buildings, they are difficult to damage or paint over, and have proved to be among the most resilient forms of street art around.

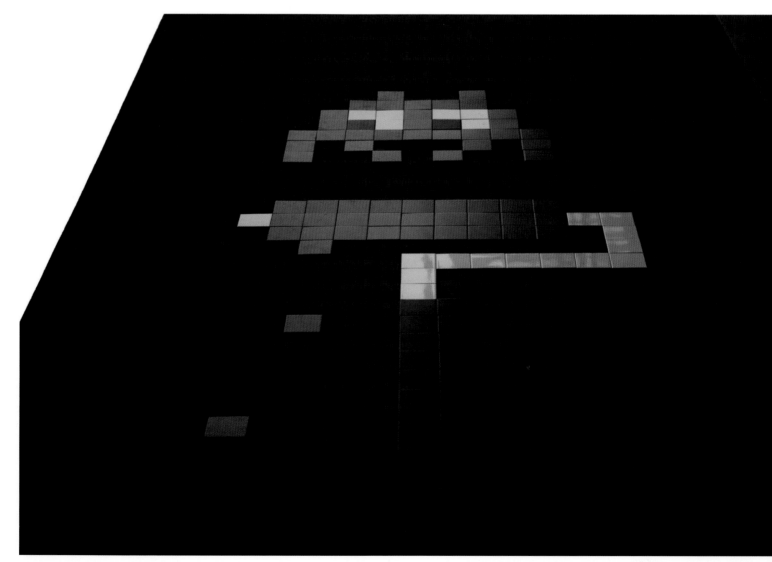

London, UK

94

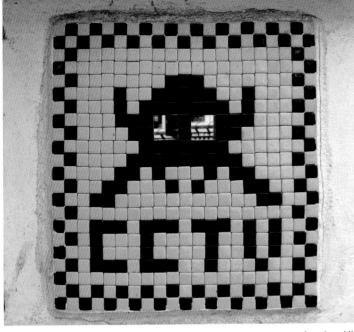

London, UK

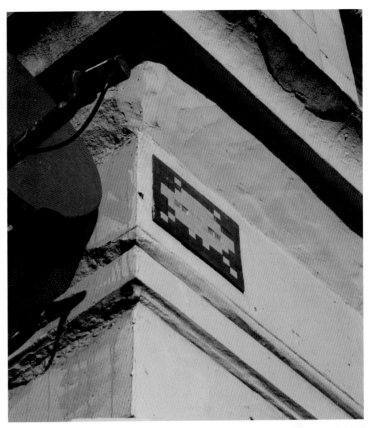

Newcastle, UK

Newcastle, UK

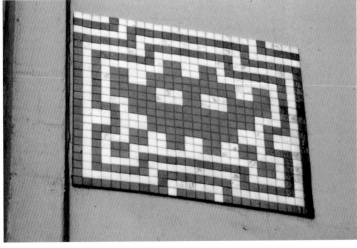

Paris, France

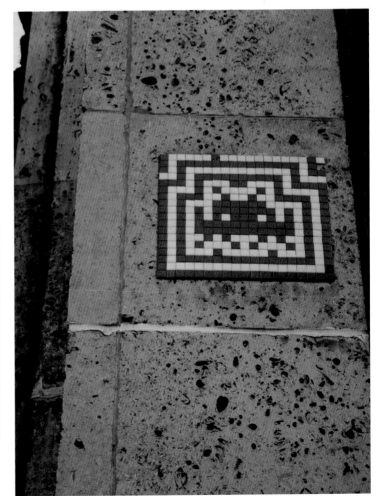

Newcastle, UK

95

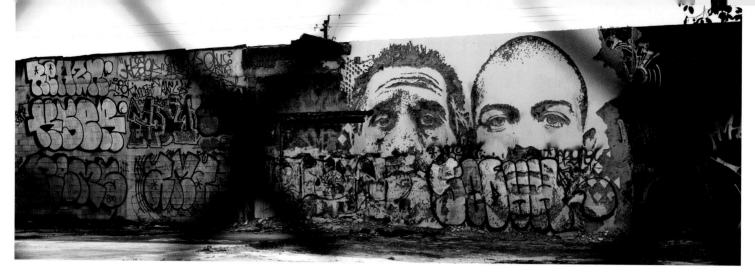

VHILS

From South Bank near Lisbon, Portugal

This rising international star and his crew create highly original work using his signature method of careful destruction and delicate rebuilding of relief sculpture that protrudes from chiselled-back walls. His pseudonym Vhils has no real meaning, but simply derives from the fastest set of letters he could apply in a hurry while working illegally.

As a teenager, he experimented with bleach and acids as agents of destruction on train exteriors and poster sites, before moving on to work with pneumatic drills to excavate sections of wall. As an archaeologist of the temporary structure, his process exposes the strata of urban layering and fills it with portraits that raise issues, pose questions and challenge perceptions.

While tearing apart the socio-historical fabric of the built environment, his methods have become less refined, as the rough process of removal and disruptive innovation is metamorphosed into staggered beauty.

This young artist has also directed a music video featuring his original 3D murals.

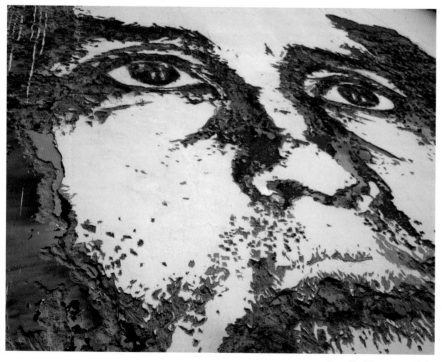

Detail of image to right

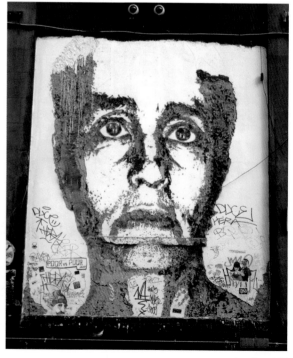

London, UK

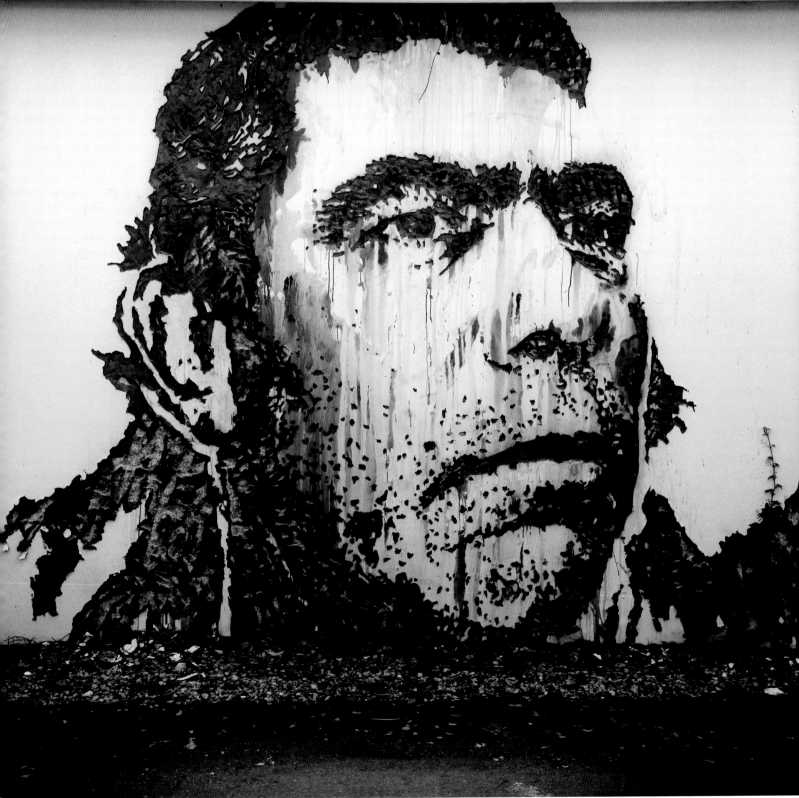

Miami, USA

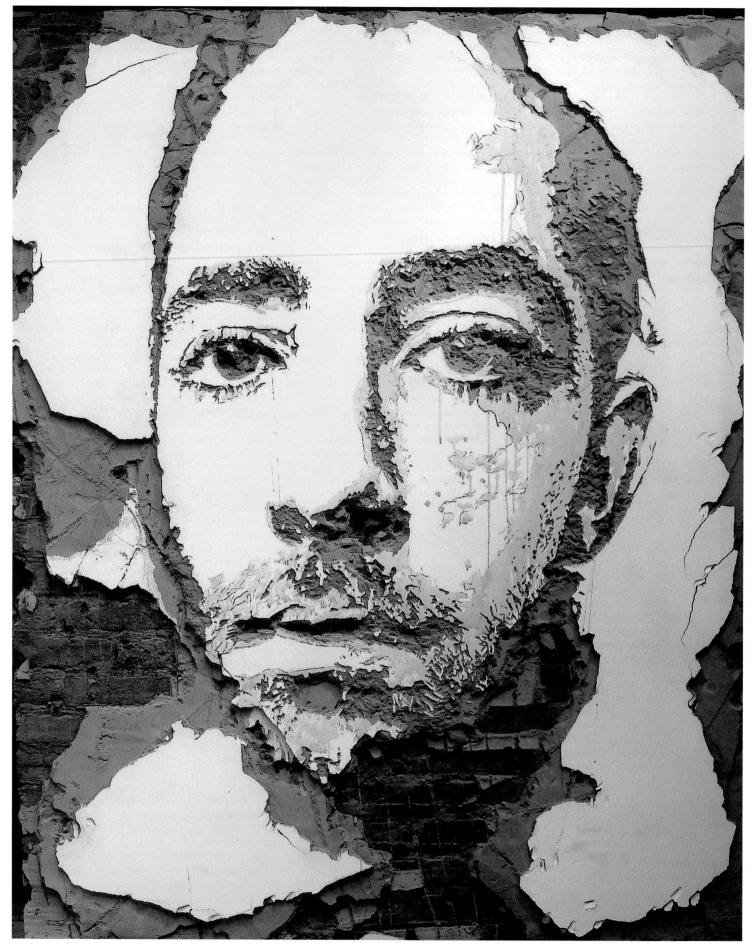

London, UK

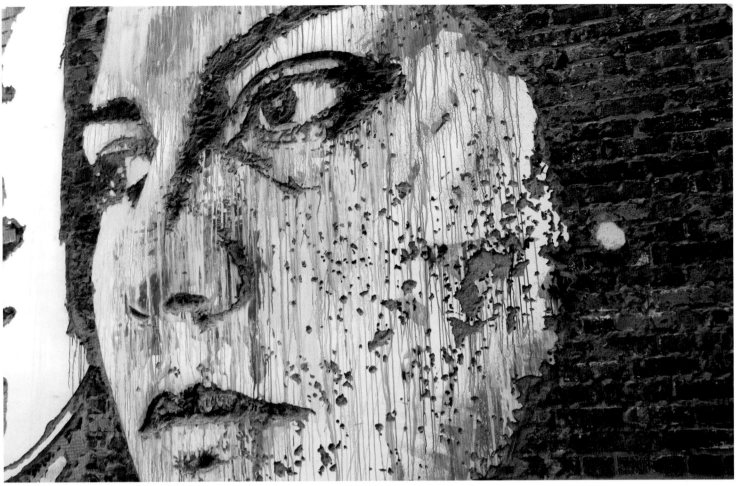

Los Angeles, USA

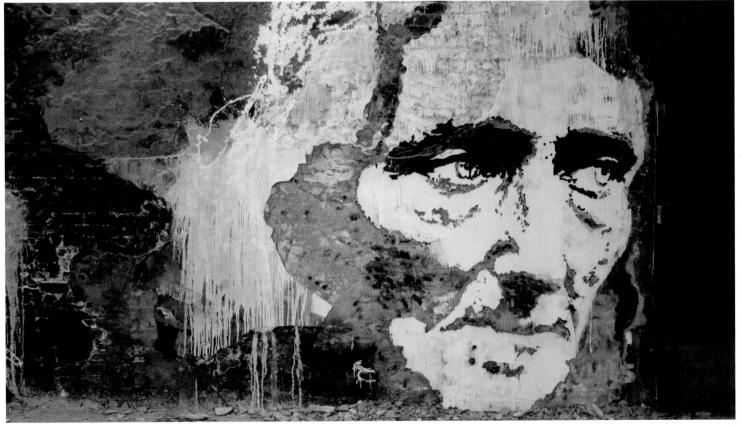

London, UK

TOOTHFISH

from Great Barrier Island, South Pacific

Toothfish began with a poster project to raise awareness of global environmental concerns that has appeared in Australia, Brazil, India, New Zealand, Ukraine, the UK and the USA. The slogan 'The War Against Nature is Over!' was particularly pertinent when posted in Japan just before the devastating tsunami in 2011. Toothfish has become a creative ambassador whose works represent the threat to the natural world from human activity.

The toothfish itself is native to the seas around Antarctica and is a species so under threat that Greenpeace are staging a campaign to highlight its plight. As it is only a matter of time before it becomes extinct, the Toothfish posters are deliberately not permanently attached to surfaces, reflecting the imminent disappearance of the namesake.

People are encouraged to interact by removing, relocating and recycling the posters in order to create or discover some context and meaning between the scene and the artwork. Accompanying the images are a request by the artist to document this process by taking a photograph and passing the images on to the Toothfish website.

Newer work includes a series of baby incubators containing Bonsai trees that are left abandoned in public spaces.

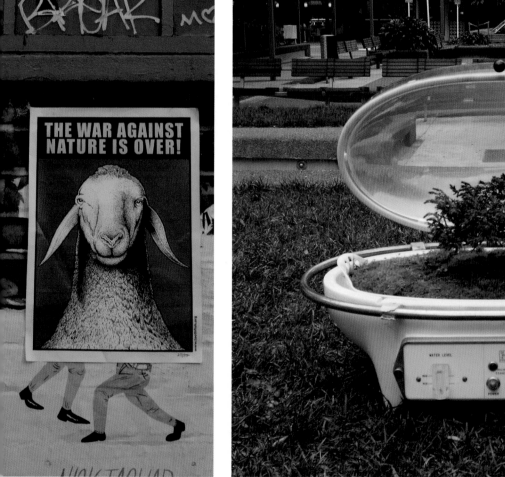

Poster in London, UK

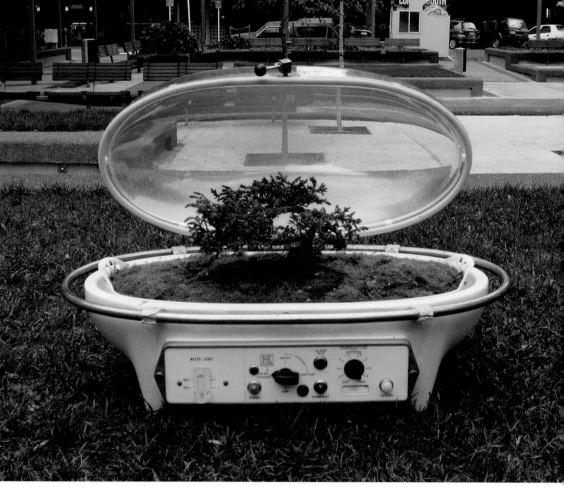

Wellington, New Zealand

Poster in London, UK

CHEWING GUM MAN

from Barnet, London, UK

The canvas of choice for this street art miniaturist is the endless multitude of thoughtlessly discarded pieces of chewing gum that litter city streets. Using enamel paint that is worked on to gum that he melts with a blowtorch, he then seals the intricate works with varnish to protect them from decay.

When Chewing Gum Man is at work, he simply initials his pieces, but he can also include other people's names and he often produces bespoke gum art for passers-by, sometimes gifting them as an expression of altruistic social cohesion. This artist is untrained and started out working with discarded wood that he transformed into larger-than-life sculptures and which were then placed in the environment. These characters display a pagan other-worldliness that has transmuted into the miniaturist work that he creates on street detritus such as cigarette butts, drinks cans and, most notably, the 10,000 pieces of chewed gum that he has patiently decorated, in situ, on the pavements of the city.

He has recently begun to create trails of gum art that respond to particular communities and that encourage the participation of schoolchildren and local residents in self-guided tours, following a trail he has left. Some pieces are portraits, many are memorials, others are simple street scenes or verbal statements against further pollution.

NEK CHAND

from Chandigarh, India

Over 40 years ago, this former transport official in the Punjab state of northern India began to secretly construct figures from waste materials that he had found. After work and under the cloak of darkness, he gradually expanded this project to occupy more and more wasteland on an outskirt of Chandigarh, a planned city in India designed by French modernist architect Le Corbusier.

When the authorities discovered Chand's work, instead of destroying the illegally created artworks, local officials decided to pay him to develop this urban garden of recycled sculptures and mosaics connected by interlinking courtyards.

Nek Chand's Rock Garden is now one of the modern wonders of the world, attracting visitors from all over the globe.

All images shown here are in Chandigarh, India

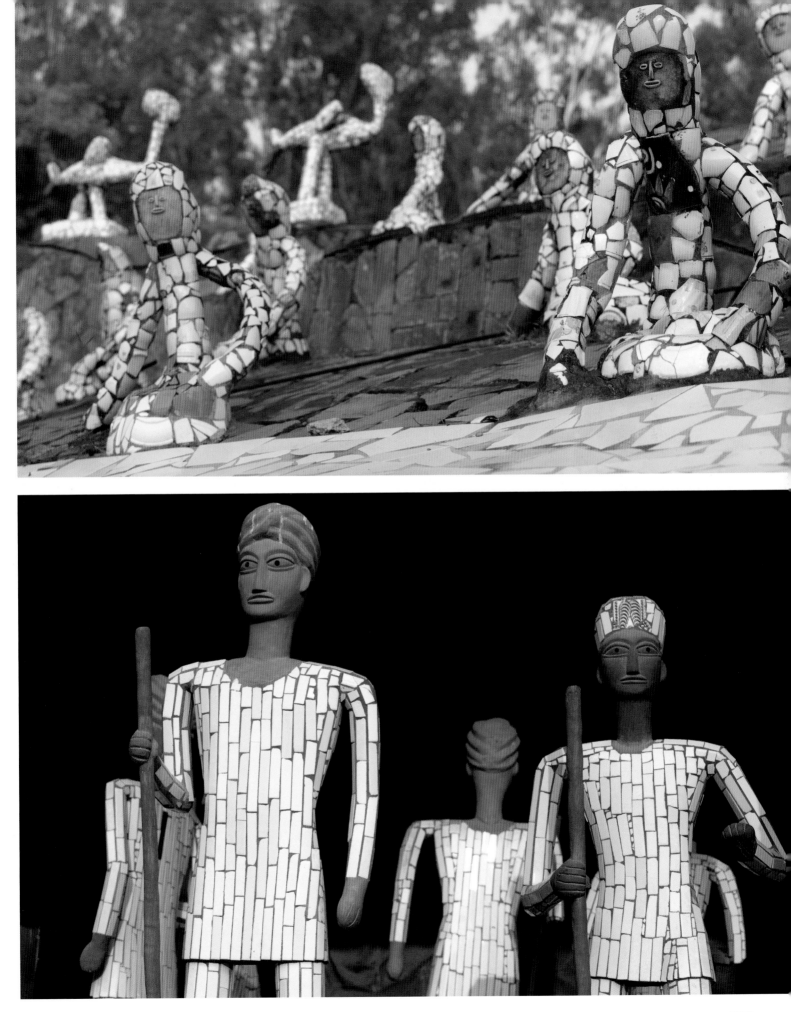

FAILE

collective from California and Minneapolis, USA and Tokyo, Japan

nitially known for stencilling and wheatpaste postering, this Brooklyn-based trio moved on to placing their work on 3D objects such as wooden crates, pallets and poles, referencing the design of religious artefacts.

Their movable wooden pieces, based on the tactile bas-relief of Tibetan prayer wheels, actively encourage audience participation and viewers are invited to touch the raised carvings and spin the separate elements.

All images shown here are in New York City, USA

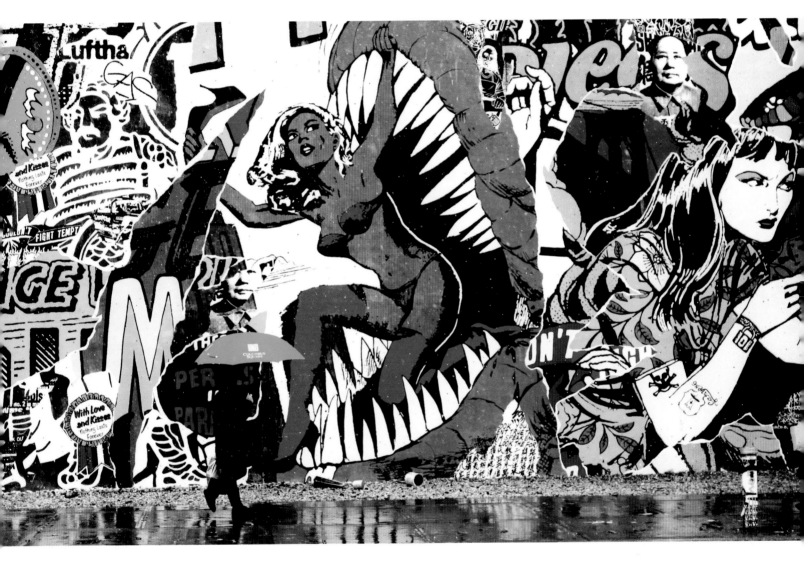

A broad renaissance in the field of craft and assemblage has seen Faile design clothing and shoes for manufacture and collaborate on music projects, with such commercial outlets financing their site-specific street installations.

Their prolific practice has seen them produce work that emerges from interiors and on to the street, with major projects sprawling out of a London school or a ruined church in Lisbon, guided by their sensibilities of improvization and innovation.

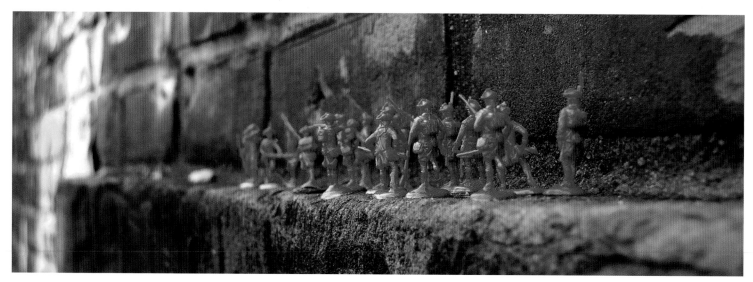

All images shown here are in New York City, USA

GENERAL HOWE

from New York City, USA

Named after the commander-in-chief of the British armies in America during the War of Independence, this artist places miniature toy soldiers and posters that site-specifically reference battles in Brooklyn during that period.

While the original General Howe was criticized for a lack of flexibility that allowed George Washington to outmanoeuvre him and led to the eventual defeat of the British, his modern namesake thoroughly researches conflict locations and adds plastic toys to those spots.

As alternative markers to decisive moments in American history, these works can be easily overlooked, but as thought-provoking 'minstallations' they encourage viewers to enjoy a search-and-find game with a political twist.

PABLO DELGADO

from Mexico City, Mexico

Known as a painter and installation artist in the gallery environment, Delgado is constantly trying out new directions, with his tiny street characters being his most visible invention. He melds new media with old, using a computer to adjust contrast or convert coloured figures to grayscale, which he then embellishes with felt-tipped pens before adding paint to create the shadows that the 2D figures 'cast' on the pavement.

His players live on the edges of society, representing outcasts who occupy street corners and dark alleys in real life, and in his minuscule dioramas they are actors frozen on paper at the bottom of buildings, casting long shadows from a mysterious backlight.

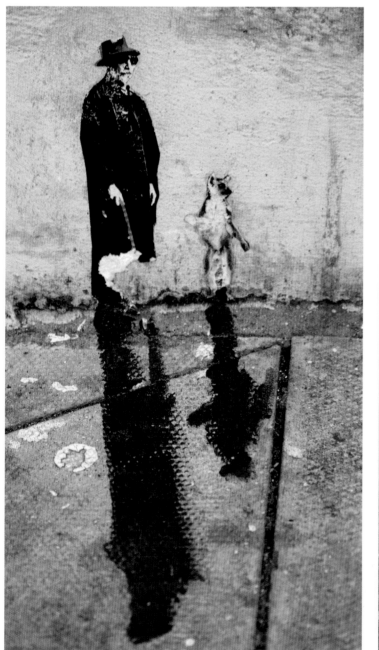

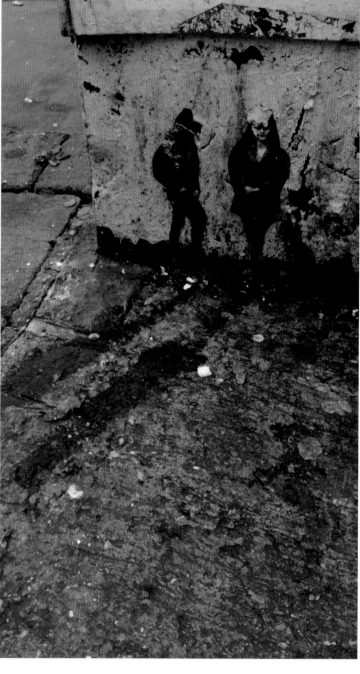

All images shown here are in London, UK

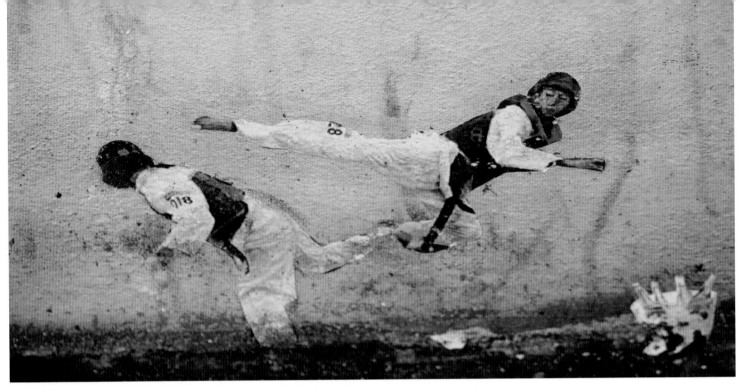

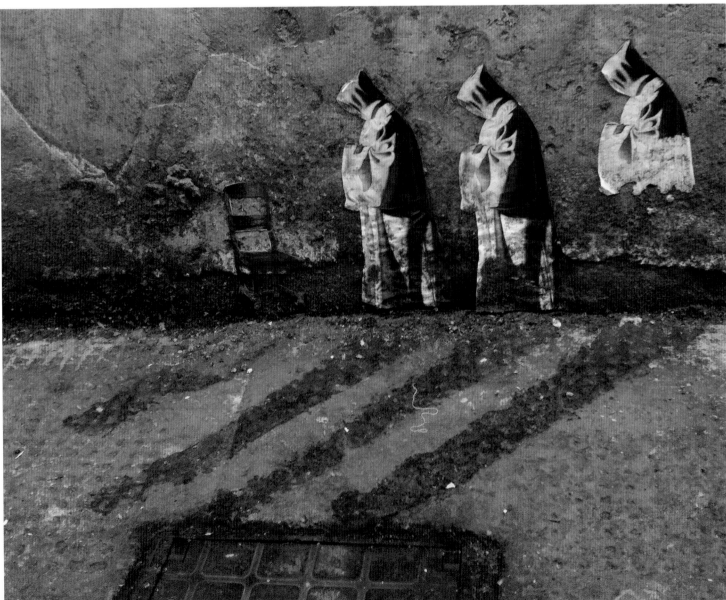

OTHER MEDIA

from around the world

Posters and stickers on a graffitied car, London, UK

Cityzen Kane, mixed media, London, UK

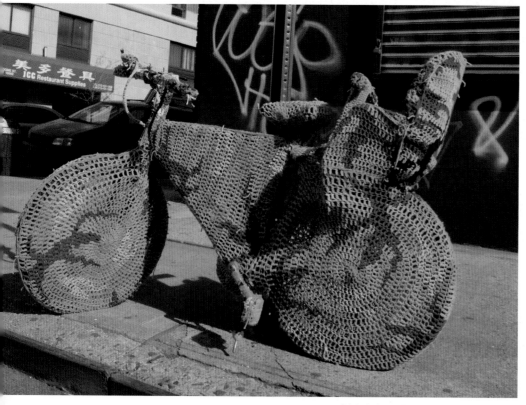

Olek, knitted bike, New York City, USA

Unknown artist, mixed media, London, UK

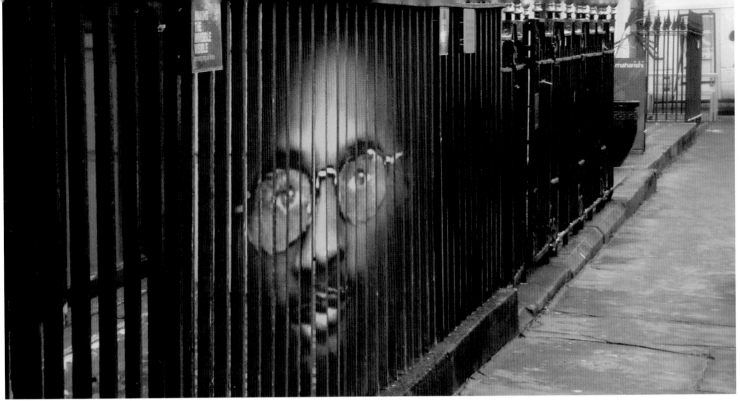

Mentalgassi, spraycan, London, UK

Karat, metal plate etching, New York City, USA

epilogue
emerging and future trends

In cities that are increasingly monitored by 24/7 CCTV, speed and lateral thinking are the essential tools of the street artist of today. Non-permanence is another good way to dodge the wrath of the law, and some artists are making use of paints that are designed to wash away in the rain.

To avoid arrest, street artists in Paris are now perfecting techniques using high-pressure hoses to carve out designs from accumulated dirt on walls. By improving upon existing urban neglect they make a statement while developing new ways of working.

In London, other non-invasive work includes lighting trails that can be witnessed on the street during their temporary existence as well as being captured on film. The work of the duo Ellis Leeper and Meena Narayana speaks of the transience of big cities, where the traces we leave as individuals are immediately swallowed by the enormity of the modern metropolis. These artists from Kentucky, USA and Bangalore, India respectively, share their experiences of migration and integration through a timed choreography of pulsing lights at major traffic junctions. This continues the tradition of street artists working at night, although darkness in this instance is preferred because it increases the visual impact of the piece rather than for its cloak of secrecy.

In São Paulo, Brazilian artist Zezão transforms subterranean tunnels into galleries, using the available light of the city that leaks underground to maximize the dark interiors and highlight his artwork. He is making a point about how years of complacency by the city's authorities have led to the regular heavy rains filling sewers with detritus from the street above.

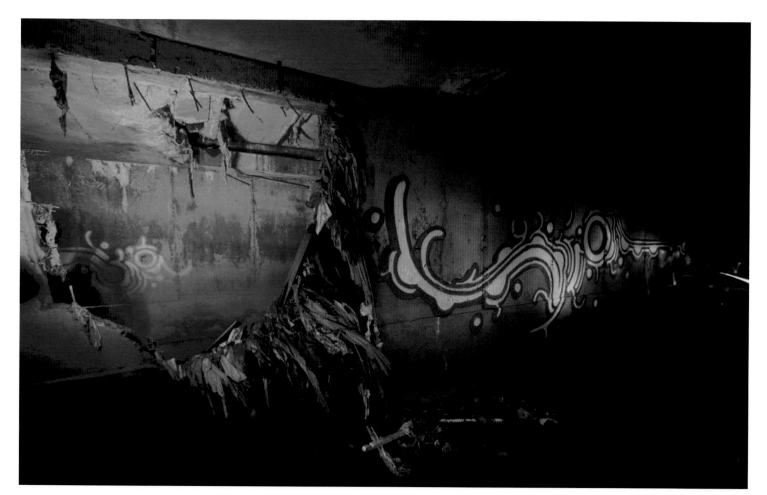

Zezão, São Paulo, Brazil

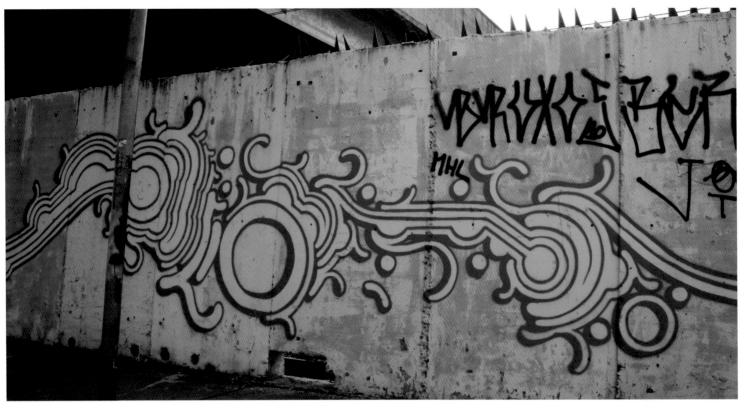

Zezão, São Paulo, Brazil

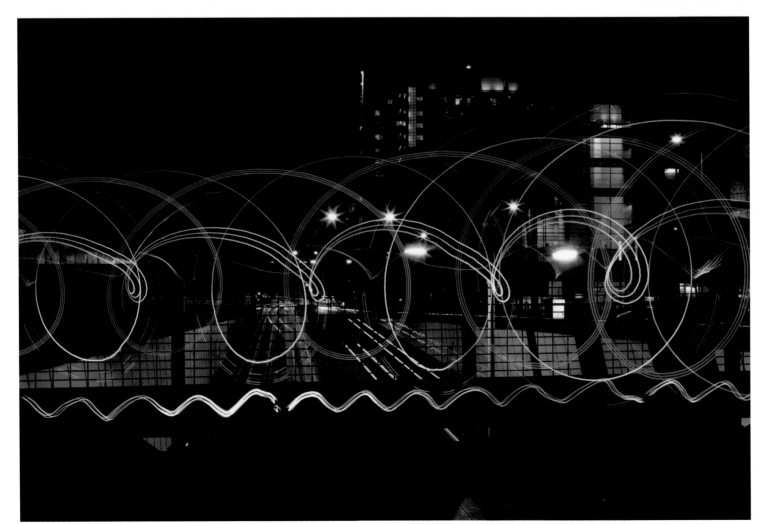

Ellis Leeper and Meena Narayana, London, UK

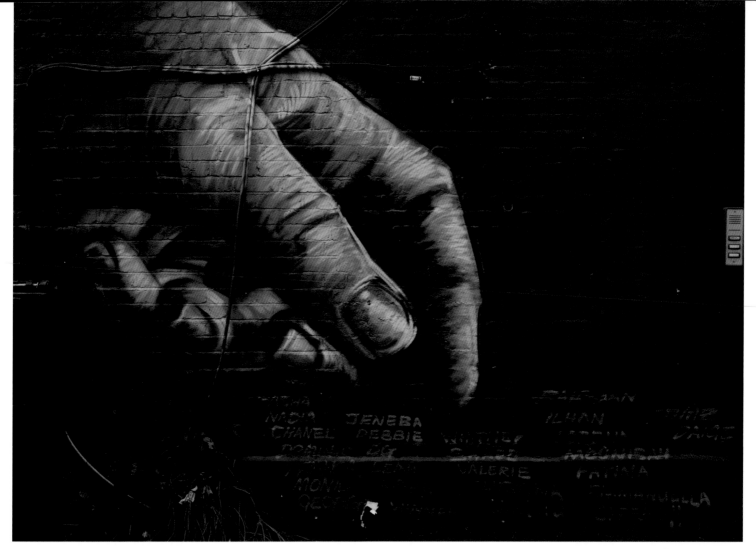

Gaia, London, UK

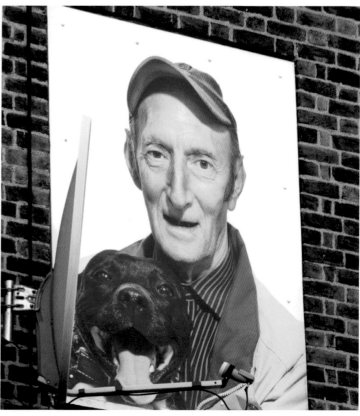

Garry Hindley, Sheffield, UK

Fugitive, London, UK

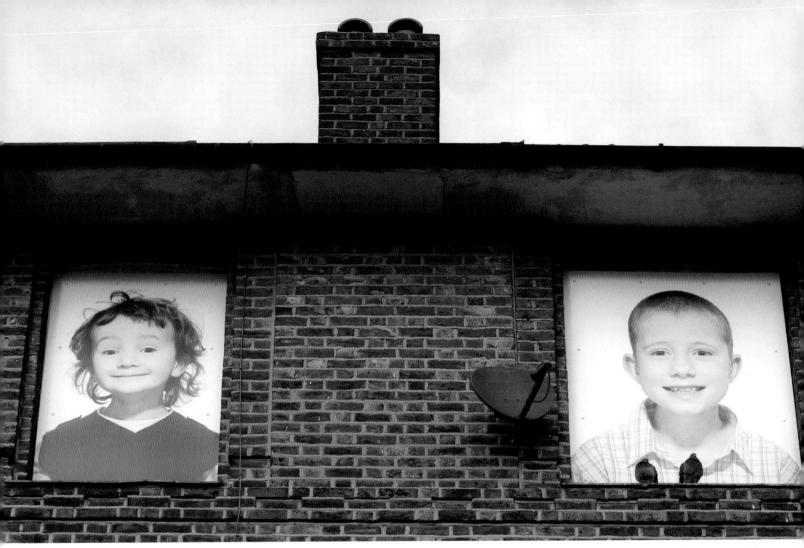

Fugitive, London, UK

COLLABORATION AND COMMUNITY

Collaboration between street artists is now common. Fewer of them seek to reoccupy a space already claimed by another artist, instead adding work that complements the existing piece. Artists such as Gaia have gone one step further, encouraging local people to participate in painting murals and including their names in the artwork.

Some town councils have embraced street art as an effective way of keeping graffiti away or focusing attention on the potential of neglected sites, whether for business or for habitation. Street art reclaims public space for the collective imagination, and is largely set apart from frustrations with politics, banking and the economy.

Influenced by the practice of JR, Sheffield painter Gary Hindley began to paint giant portraits of former residents of the abandoned Park Hill complex in the city. His source material was a TV documentary made when the huge complex was built in the 1960s, but people began to come forward to share their stories about living there as this artist's project expanded and he attached the finished works directly to the building.

In London, Fugitive have photographed people who lived in a large public housing estate by the canal in Hackney and sensitively mounted enlarged portraits of them on the outside of the buildings. These fit within the window frames that they would have until recently looked out of.

Community practice now has a major presence all around the world, with localism being the key issue for many schemes, from Brazil to Thailand and across the Pacific. Around the Toi Poneke hub of Wellington, New Zealand, street artists blend ancient Maori lore with current environmental issues, often commissioned by Wellington Arts Programmes Director Eric Vaughn Holowacz. Notable amongst these is the Deep Sea Food-chain by Bruce Mahalski (see overleaf) which was inspired by his work with Learning Media at local colleges and residencies at marine education centres. This non-formally trained artist has a degree in psychology as well as a passion for the natural world and indigenous cultures, demonstrating the fact that street art can often be best achieved by those less influenced by art school studies.

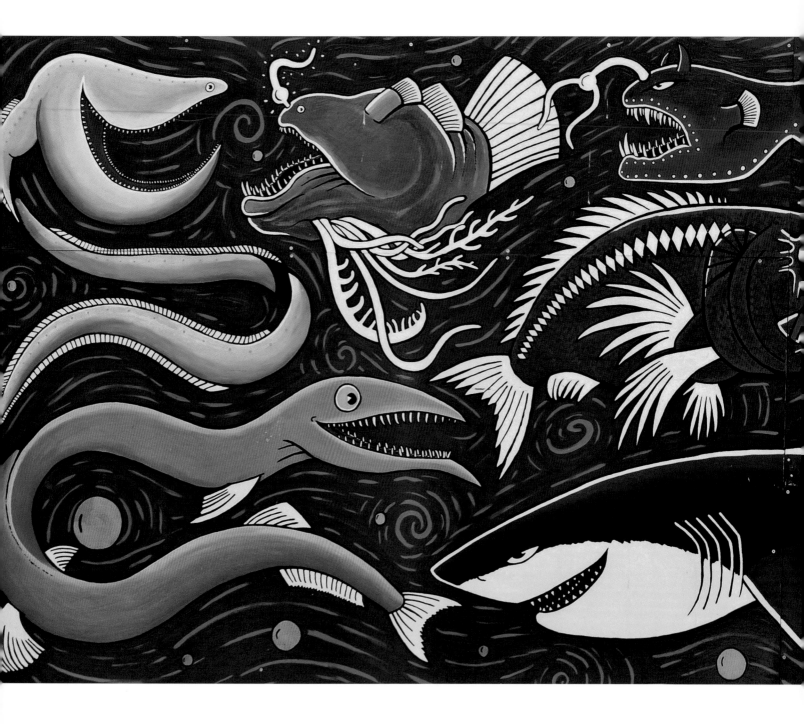

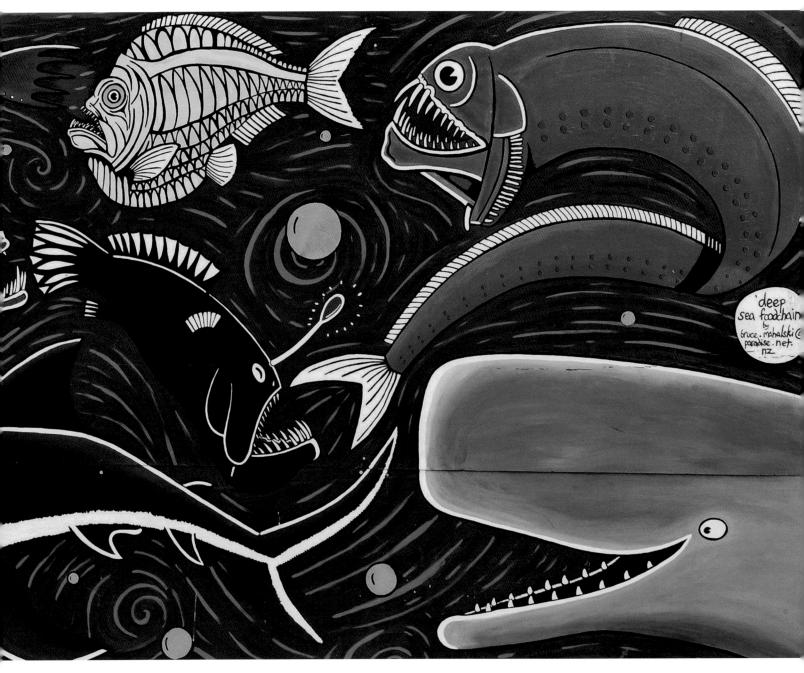

Bruce Mahalski, Wellington, New Zealand

Mural including Kid Acne, Sheffield, UK

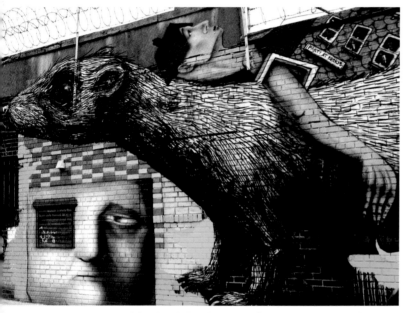

Mural with Roa, Veng and Overunder, New York City, USA

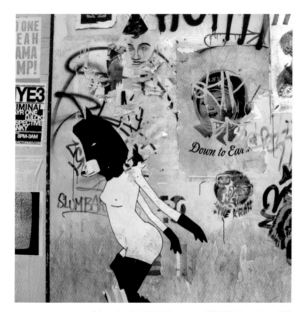

Mural with Kid Acne and EMA, London, UK

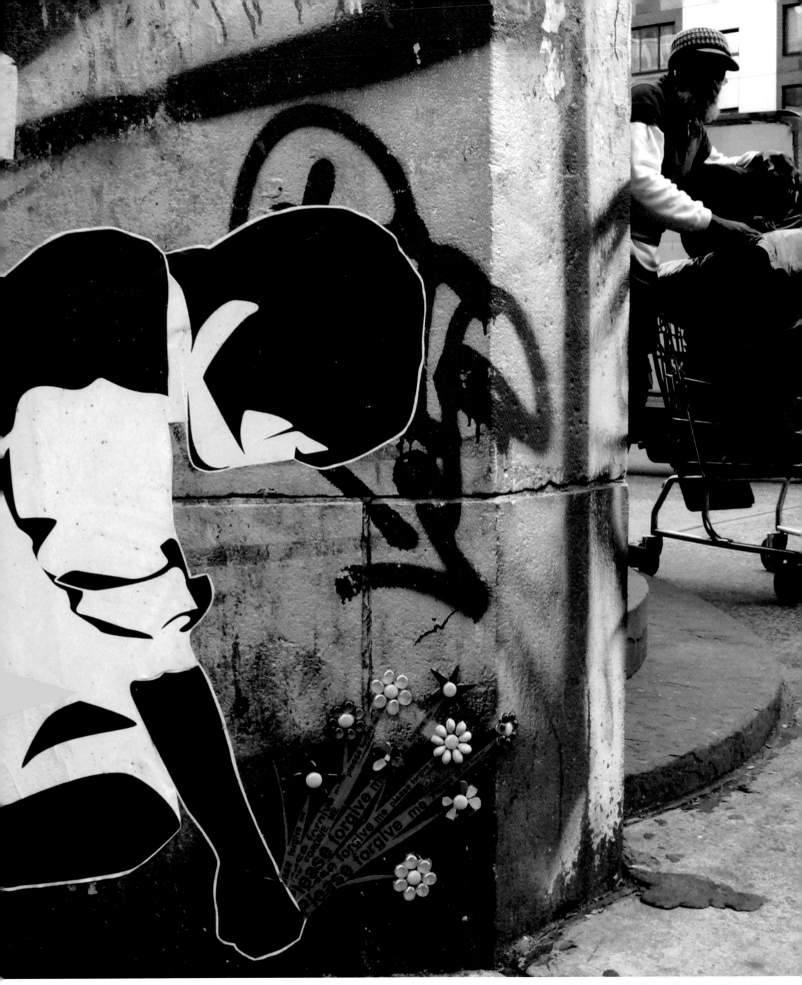

Main figure by an unknown artist and beaded bouquet by Wing, New York City, USA

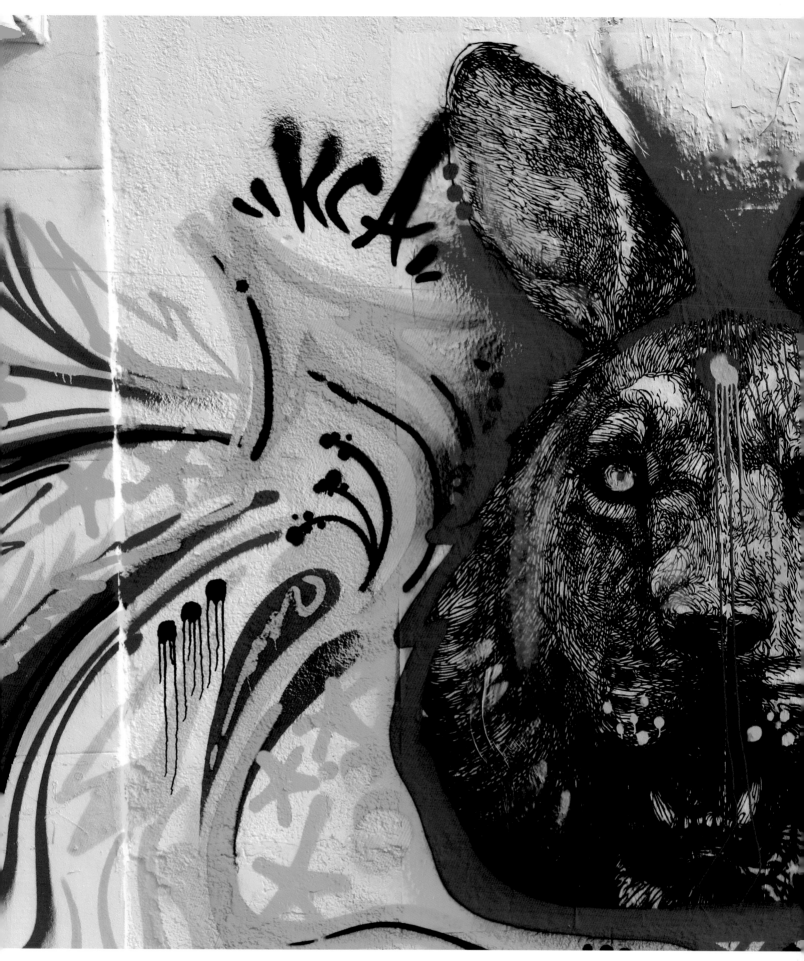

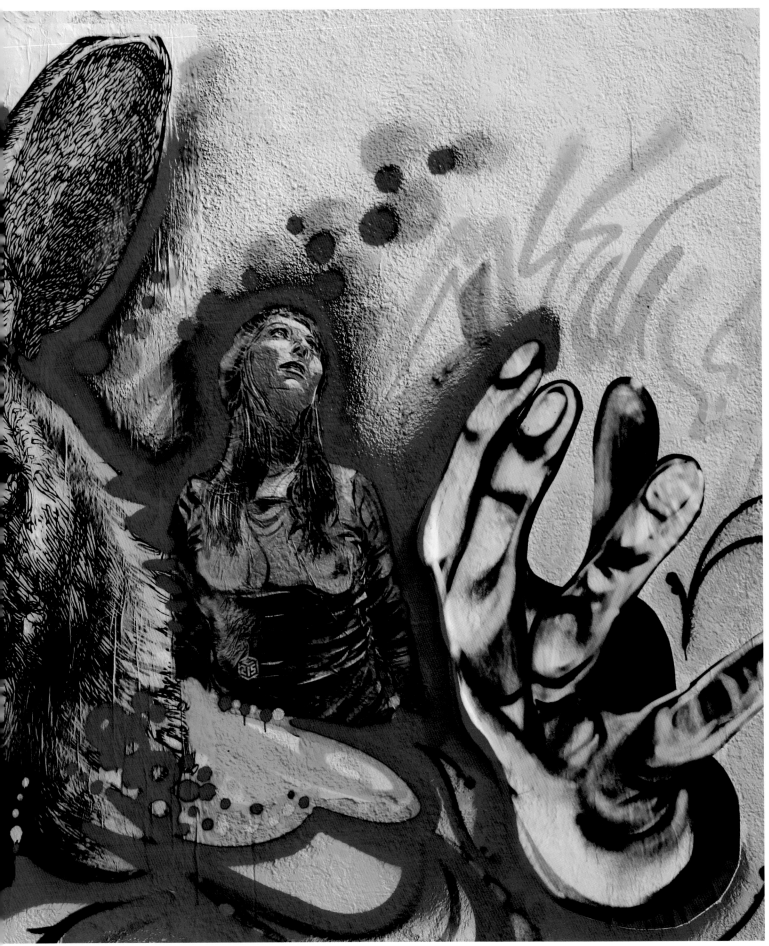

Mural with Gaia and C215, Miami, USA

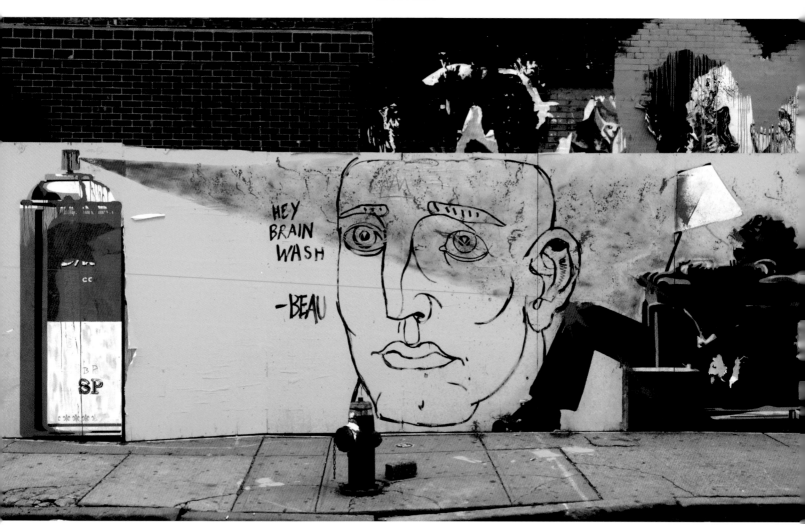

Mural with Mr Brainwash and Beau, New York City, USA

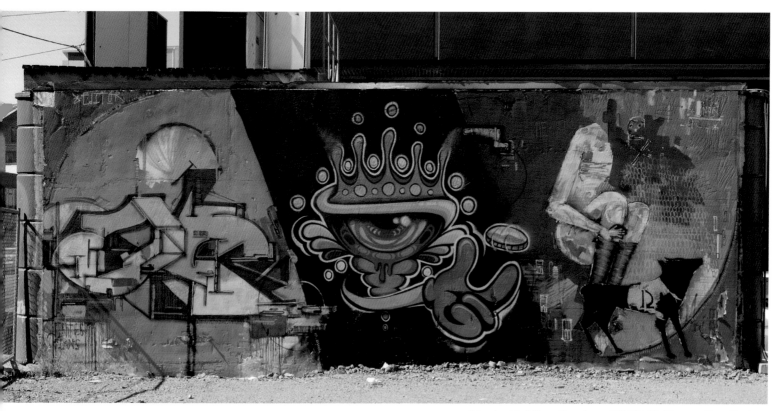

Mural with Editor, Ghostie and PNTR, Wellington, New Zealand

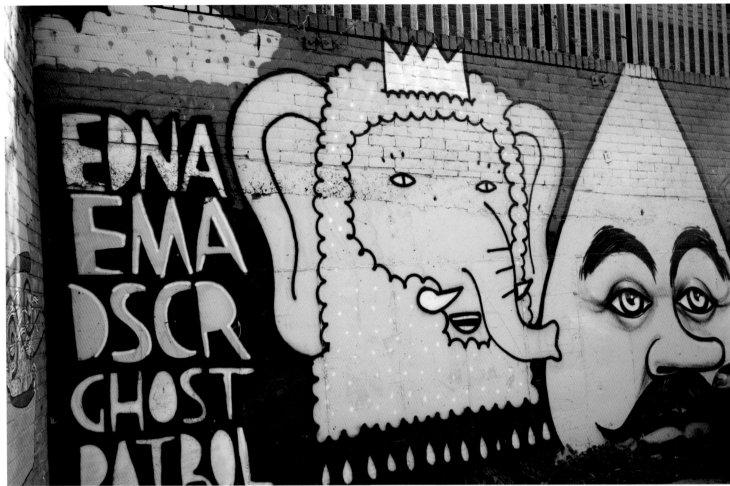

Mural with EDNA and EMA, London, UK

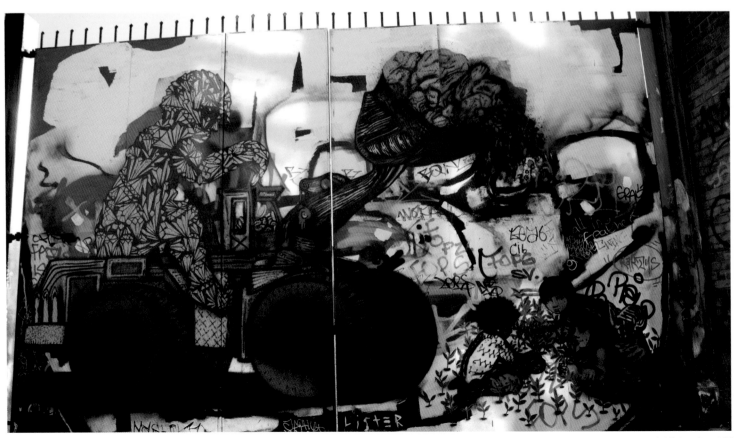

Mural by Lister with other artists overlaid, London, UK

INTO THE MAINSTREAM

Institutions such as Tate Modern in London and the Museum of Modern Art in New York have showcased street artists who are now nurtured by the establishment. This raises the question, can the art, now located inside a prestigious building, still be called 'street art'?

There is no doubt that big businesses and advertising agencies are using the medium as a way of making their products more 'hip' and increasing their sales to a young audience, but this is not necessarily a bad thing. After all, they are recognizing the merits of the artworks, as well as preserving them. Many artists go on to use the money they earn to fund future projects as well as giving back to the communities that inspired them in the first place. The vast majority of street art remains out there in the public domain, with new artists regularly making their street debuts. Even works by such global stars as Banksy can still be painted over by local councils, as happened with his famous *One Nation Under CCTV* piece in London's

West End, proving that the essential temporal nature of most street art still remains true.

Works by leading street artists such as Banksy command huge prices in the commercial gallery and the auction house. In 2008, Christie's recognized the importance of international street art by commissioning UK/Latin American collective Mas Civiles to produce a large-scale collage of urban art that hung from the auction rooms. This whole work was then exhibited in the 'cave' (or cellar) at a crumbling chateau in the Ardèche, inviting comparisons with those cave paintings from many centuries before, in the same region of South Central France. The collaborative nature of the piece, which features work by eight people – including photographer Harry Urgent, painters Scarlet Raven and Graham Carrick, graphic artist Russell Clark and urban artists Manuel Sanmartin, Janina Langton and Rhea Nielsen – can also be linked to those ancient artworks, bringing us full circle back to where it all began.

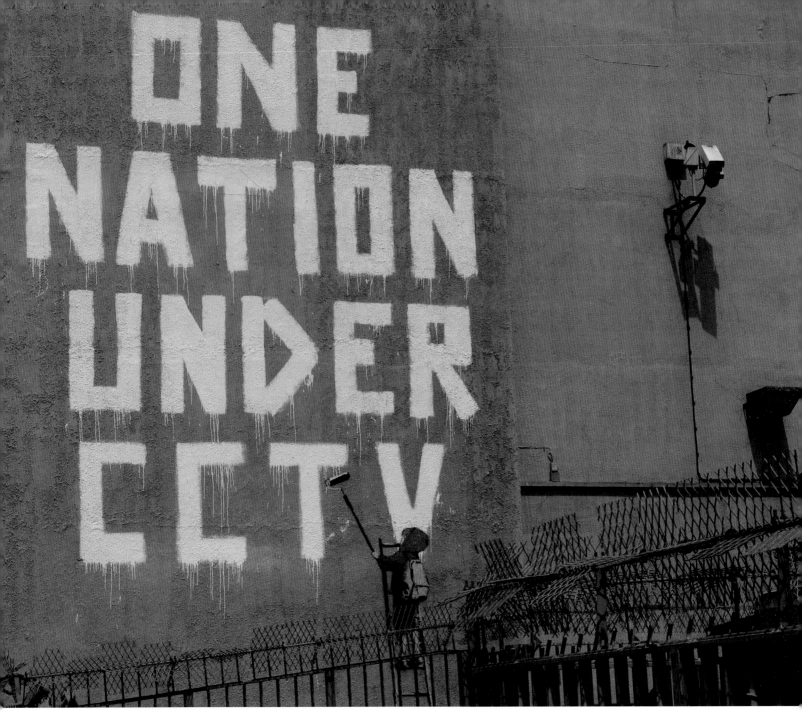

Banksy, London, UK

Mas Civiles, collaborative mural 'La Cave', Ardèche, France

PHOTO CREDITS

Jaime Rojo at Brooklyn Street Art

17, top: Banksy, New York City. Photo © Jaime Rojo

19: Banksy, New York City. Photo © Jaime Rojo

21, top right: Banksy, Chicago. Photo © Jaime Rojo

24–25: C215, New York City (4 images). All photos © Jaime Rojo

36–39: Shepard Fairey, New York City (7 images). All photos © Jaime Rojo

42, top: Swoon, New York City. Photo © Jaime Rojo

44, bottom right and 45 bottom left: EMA, New York City. Photos © Jaime Rojo

48–49: JR in Miami and New York City (4 images). All photos © Jaime Rojo

52–53, bottom centre, 53 top left and right (3 images): Gaia, New York City. Photos © Jaime Rojo

54–55: Gaia, Miami. Photo © Jaime Rojo

56, top left: Aiko and Bast, New York City. Photo © Jaime Rojo

57, top left: Primo and Kid Acne, New York City. Photo © Jaime Rojo

57, top right: Willow, New York City. Photo © Jaime Rojo

60–61: Barry Magee, Miami (5 images). All photos © Jaime Rojo

62, top: Blu, New York City. Photo © Jaime Rojo

68–69: Roa, Miami. Photo © Jaime Rojo

81: Eine and Spencer Keeton, Miami. Photo © Jaime Rojo

85: Os Gêmeos, Miami. Photo © Jaime Rojo

87, top left and right: Os Gêmeos, Miami. Photos © Jaime Rojo

96, top: Vhils, Miami. Photo © Jaime Rojo

97: Vhils, Miami. Photo © Jaime Rojo

106–107: Faile, New York City (4 images). All photos © Jaime Rojo

108–109: General Howe, New York City (3 images). All photos © Jaime Rojo

120: mural with Roa, Veng and Overunder, New York City. Photo © Jaime Rojo

121: mural unknown artist and Wing, New York City. Photo © Jaime Rojo

122–123: mural with Gaia and C215, New York City. Photo © Jaime Rojo

124, top left: mural with Mr Brainwash and Beau, New York City. Photo © Jaime Rojo

Doralba Picerno

10, right: Thierry Noir, Berlin. Photo © Doralba Picerno

11, top right: Banksy/Robbo, London. Photo © Jon Knox

15, bottom right: Blek le Rat, Berlin. Photo © Doralba Picerno

31, centre left: Don, London. Photo © Doralba Picerno

33, top right: unknown artist, London. Photo © Doralba Picerno

62, bottom: Blu, Berlin. Photo © Doralba Picerno

64, left: Blu, Berlin. Photo © Doralba Picerno

66–67: Roa in Berlin and London (5 images). All photos © Doralba Picerno

70, top left and right: Jimmy C, London. Photos © Doralba Picerno

79, top, bottom left and bottom right (3 images): Stik, London. Photos © Doralba Picerno

80, top right: Eine, London. Photo © Doralba Picerno

89, top right: Cassette Lord, Brighton. Photo © Doralba Picerno

89, bottom: Motor, London. Photo © Doralba Picerno

91, centre right: Malarky, London. Photo © Doralba Picerno

91, bottom left: Victor Ash, Berlin. Photo © Doralba Picerno

112, top right: Cityzen Kane, London. Photo © Doralba Picerno

125, top: mural with EDNA and EMA, London. Photo © Doralba Picerno

125, bottom: mural with Lister, London. Photo © Doralba Picerno

Other photograph credits

6, bottom: Paleolithic cave painting. Photo © Corbis

8–9: 5Pointz Aerosol Center, NYC. Photo © Catherine Gibbons

11, bottom right: Keizer, Cairo. Photo © Gigi Ibrahim

14: Blek Le Rat, Paris. Photo © Olivier Rouillard

15, left and top right: Blek Le Rat, Paris. Photos © Olivier Rouillard

18: Banksy, London. Photo © Sheridan Orr

26–27: C215, Vitry-sur-Seine and Paris (6 images). All photos © Marie Aschehoug-Clauteaux

32, top right: Jef Aérosol, Paris. Photo © Marie Aschehoug-Clauteaux

33, bottom right: Jef Aérosol, Paris. Photo © Marie Aschehoug-Clauteaux

33, top centre: Keizer, Cairo. Photo © Gigi Ibrahim

40, top right: Swoon, London: Photo © Marie Aschehoug-Clauteaux

40, bottom right: Swoon, New Orleans. Photo © Rex Dingler

42, bottom: Swoon, New Orleans. Photo © Rex Dingler

46, top left: JR, London. Photo © Marie Aschehoug-Clauteaux

46, bottom: JR Los Angeles. Photo © Ted Soqui/Corbis

47, top centre: JR, Paris. Photo © Marie Aschehoug-Clauteaux

47, top right, centre right and bottom: JR Los Angeles. Photos © Ted Soqui/Corbis

52, bottom left: Gaia, Los Angeles. Photo © Lord Jim/Stefan Kloo

53, bottom right: Gaia, Los Angeles. Photo © Lord Jim/Stefan Kloo

63: Blu, Berlin. Photo © Wolfram Steinberg/dpa/Corbis

65: Blu, Berlin. Photo © Wolfram Steinberg/dpa/Corbis

80, bottom: Eine, London. Photo © Marie Aschehoug-Clauteaux

82, bottom left: BMD, Wellington. Photo © James Gilberd/Photospace

83, bottom: BMD, Wellington. Photo © James Gilberd/Photospace

84, top: Os Gêmeos, Lisbon. Photo © Alessandro della Bella/keystone/Corbis

84, bottom: Os Gêmeos, Los Angeles. Photo © Lindsay T.

86, left: Os Gêmeos, São Paulo. Photo © Jack Zallum

87, bottom: Os Gêmeos, Lisbon. Photo © Alessandro della Bella/keystone/Corbis

88, top left: unknown artist, Rio de Janeiro. Photo © David Bank/JAI/Corbis

89, top left: unknown artists, Ibiza. Photo © Ellis Leeper

90, top left and **title page**: Herakut, Los Angeles. Photo © Lord Jim/Stefan Kloo

90, centre and bottom left: David Walker, London. Photos © Marie Aschehoug-Clauteaux

95, bottom left: Invader, Paris. Photo © Marie Aschehoug-Clauteaux

98, Vhils, London (gallery piece). Photo © Marie Aschehoug-Clauteaux

99, top: Vhils, Los Angeles. Photo © Lord Jim/Stefan Kloo

99, bottom: Vhils, London. Photo © Anya Greenleaf

110, bottom right: Pablo Delgado. Photo © Lucietta Williams

111, bottom: Pablo Delgado. Photo © Lucietta Williams

112, bottom left: Olek, New York. Photo © Lord Jim/Stefan Kloo

113, top: Mentalgassi, London. Photo © Marie Aschehoug-Clauteaux

113, bottom: Karat, New York. Photo © Lucietta Williams

114, bottom: Zezão, São Paulo. Photo © Zezão

124, bottom: mural with Editor, Ghostie and PNTR. Photo © James Gilberd

127, top: Banksy. Photo © Julian Tysoe

All other photos including that on the front cover are by the author, Garry Hunter.